PRAISE FOR
You Can Draw in 30 Days

"Sharpen your pencils and open your sketchbook; your teacher is waiting."
> —*Boston Globe*

"The book offers a set of valuable introductory lessons in putting what you see—in the real world or your mind's eye—down on paper."
> —**Infodad.com**

"A must for anyone who wants to pursue art but doesn't know where to start."
> —*Midwest Book Review*

"Kistler provides detailed instructions and tips that take the mystery out of making simple drawings that look good. He also uses a sense of humor and encouraging words to help."
> —*Deseret News*

"Kistler's approach is light and fun, and rather than overwhelming with technical terminology and intimidating concepts, he instead starts you out putting pencil to paper. Within the first few pages of the book, you are already well on your way . . . The approach presented in this book works so well because you get instant results, which inspire you to continue with the process."
> —*Sacramento Book Review*

You Can Draw It in Just 30 Minutes

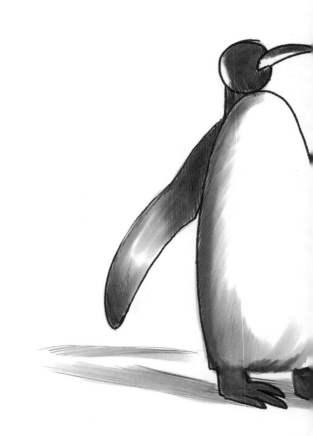

You Can Draw It in Just

30

MINUTES

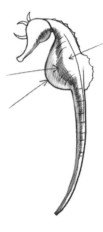

See It and Sketch It in a Half-Hour or Less

Mark Kistler

Da Capo

∞

LIFE
LONG

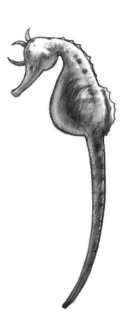

Wonderful guest art provided with the kind permission of:
Siera Pritikin (boot) and Rod Thornton (tree frog).

Designed by Trish Wilkinson

Cataloging-in-Publication data for this book is available from the Library of Congress.

First Da Capo Press edition 2017
ISBN: 978-0-7382-1862-5 (paperback)
ISBN: 978-0-7382-1863-2 (e-book)

Published by Da Capo Press, an imprint of Perseus Books, LLC, a subsidiary of Hachette Book Group, Inc.
www.dacapopress.com

Da Capo Press books are available at special discounts for bulk purchases in the U.S. by corporations, institutions, and other organizations. For more information, please contact the Special Markets Department at Perseus Books, 2300 Chestnut Street, Suite 200, Philadelphia, PA, 19103, or call (800) 810-4145, ext. 5000, or e-mail special.markets@perseusbooks.com.

LSC-C

10 9 8 7 6 5 4 3 2 1

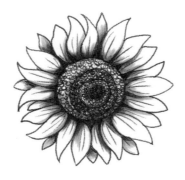

*For Joyce Kistler and Harry Schurch:
my parents and personal heroes.*

Contents

INTRODUCTION

Drawing can be terrifying.

I've taught millions of people to draw, and I see it all the time: the empty white page breeds pencil paralysis. Why? We don't know where to start and we fear "getting it wrong." Yet once I get my students to begin, to just touch pencil to paper, most of the time they fall in love with drawing.

Not only that, but people also assume that learning to draw involves a huge time commitment. They envision spending hours in front of a bowl of fruit or setting aside whole afternoons for sketching at an art museum. Certainly you could do these things. But you don't *need* a big block of time or any special location to get going.

That's why I decided to create a system for *anyone*—yes, that means you!—to *quickly* craft a realistic drawing. To draw anywhere, whenever the urge strikes, and to finish in a half-hour or less. Even if you're brand-new to drawing!

Will such fast work be perfect? Of course not. But the more you practice, the less nervous you'll feel about the outcome and—surprise!—your drawings will improve. My own drawings often don't turn out the way I planned; I recycle *a lot* of paper full of unsuccessful scribbles. I've been drawing for a lifetime, and I still learn every day. But I don't worry about it, and I hope, more than anything, that *You Can Draw It in Just 30 Minutes* frees you from drawing anxiety and helps you have fun and enjoy the process of learning to draw.

Here are the three simple elements that make this method work:

1. THE BLUEPRINT

Using my 30-minute system, during the first few minutes of each drawing lesson you'll create a **blueprint** of the drawing. In this phase I guide you to see and sketch not the object itself but the basic geometric shapes comprising it—shapes like triangles, rectangles, circles, and squares.

My plan is wily. I want to move you quickly away from "drawing" on that daunting blank page and into "refining" the shapes you've drawn. I want you out of your

head and into the art zone. That's a fun place to be. That's where creativity flourishes. Self-consciousness and self-doubt are the creativity killers my 30-minute system is designed to help you break through.

Once your time is up and your drawing is down, polish it—or erase it, or scribble over it, or color it, or crumple it. (I recommend you keep it, even if you hate it. Come back to it after you've completed a few more drawings—you'll be amazed to see how far you've come!)

2. THE NEED FOR SPEED

Nothing breaks through an artist's block like a deadline, even if it's one you impose on yourself. So for each step of the lessons in this book I include recommended time limits—five- or ten-minute segments. Yes, I want you to set an alarm while you draw. Not kidding! Haste makes no waste if it means you get a drawing completed, no matter what it looks like.

If you run out of time in a given phase, go to the next step.

I encourage you to try each 30-minute drawing several times. Eventually you can take your time with these sketches if you want to. But the first time, go fast! So fast you're running far ahead of that inner voice telling you, "You can't do this."

3. THE HACK

Drawing fast and starting with a simple **blueprint** are two key parts of my devious plan to get you drawing and enjoying it (cue maniacal laugh). The third essential element is the "hack"—an easy trick to help you more accurately place parts of your drawings on the page.

The word "hack" may bring to your mind a person who produces pretty crummy work or the act of circumventing a computer's security system. Recently, though, the term is used to describe clever and quick workarounds for life's sticky problems, like how to slice an onion without crying (freeze it for ten minutes first!). This book is full of drawing hacks. In every drawing lesson I suggest shortcuts you can take, like tracing your pocket change to draw a circle, using the edge of your credit card to get your lines straight, or tracing your pinky or thumb to draw an oval.

My friends, this isn't cheating. Artists have used tools and aids for millennia, from the apprentices hired by Da Vinci through Disney and beyond, to the projectors used by Warhol, and certainly including the computer drawing and animation tools so readily available to all of us today. Something as simple as tracing a coffee cup to draw a circle is a tool, not a cheat. It will help you learn to translate what you see more accurately to the paper in the many freehand drawings I expect you'll be

doing in the future. And even if you're never able to draw a circle without that mug, you don't have to worry about it and instead can free your mind to color creatively or embellish.

WHAT ABOUT CREATIVITY? ORIGINALITY?

In thirty years of teaching drawing the most common criticism I get is, "You teach people to copy what you're doing!" I can just hear the naysayers: "Now you're using hacks! Where's the creativity in that?" My reply: take a lesson with me and you'll see. Success in drawing now inspires creativity later.

Of course, to become proficient you'll need to practice. But I believe the prevailing methods of teaching drawing generate an awful lot of abandoned efforts in childhood and artistic blocks later in life. Many teachers still follow the method taught by Kimon Nicolaides. In his 1938 book *The Natural Way to Draw* Nicolaides says, "The sooner you make your first 5,000 mistakes, the sooner you'll learn to correct them." In reality, I think that only people with a rare, natural sense of how to draw what they see benefit from the trial-and-error method. They already have the self-reliance the rest of us are trying to develop. I love the Nicolaides book, but I believe people who experience some bit of early success and a sense of mastery tend to come back time and again to creative endeavors. I don't mean a "trophy-for-every-player" kind of reward, just enough of a recognizable drawing to feel encouraged to keep trying and build some resilience.

My lessons will give you confidence, encouragement, and basic skills. I promise: creativity will come. The more success you find with copying and hacking, the more eager you will feel to draw on your own. Moreover, as you develop artistic technique by copying shapes and shading, you will learn to see the whole world through the eyes of an artist. My goal: I want to make this book obsolete for you. Its lessons and tools will enable you to eventually create **blueprints** and refined drawings without it. When that happens, give the book to a friend and spread the joy of drawing around the world!

I *strongly* don't recommend exact copying or aiming for perfection, by the way, as you'll see throughout these pages!

30 DAYS VS. 30 MINUTES

My first book for adults, *You Can Draw in 30 Days!,* inspired me to write this new book. *30 Days!* is a drawing school in a book, with 30 lessons that each build on the previous lesson. As I watched students use that book, I noticed how satisfied they felt each time they completed an individual lesson. I realized I could take my dream

of getting *everyone* to feel confident drawing *anytime, anywhere* even further. So I devised this system enabling people to complete entire drawings—as opposed to pieces of drawings—in only a half-hour.

You Can Draw It in Just 30 Minutes! complements *You Can Draw in 30 Days!* You'll enjoy using the lessons in this book to practice the techniques you learned in *30 Days*, but the books are very different, and you don't need my first book to get full value from this one.

WHAT YOU'LL FIND IN THIS BOOK

Each chapter is a complete drawing lesson, and all pretty much follow the same structure:

1. Every chapter opens with a personal anecdote, a photo of the object you'll be drawing, a list of tools you'll need, and a list of basic geometric shapes in the drawing. I also share the location where I'm drawing the lesson—to show that you can draw *anywhere*!—and the tools I'll have on hand to use as hacks.

2. Next are a couple of instructional pages filled with hacks, tips, and techniques. ***I recommend you read these pages and practice the techniques before embarking on the drawing itself.*** I call identifying the basic geometric shapes in an object *deconstructing* the object. These instructional pages begin with a photo of the object we'll be drawing next to a deconstructed version of the object so you can see exactly what that looks like and how to do it. After this opening section I provide tips, measuring shortcuts, and explanations of any steps in that lesson's 30-minute drawing that might be confusing or complex. I'll also introduce you to some artistic terms, like **perspective** and **contour**, on a very practical level. (For handy reference, at the end of the book is a glossary with further explanations of the art terms and techniques I use in this book. Check it out on page 161.)

3. Each chapter contains a double-page spread on which you'll craft your 30-minute drawing without needing to turn any pages. On the left side are drawing instructions; on the right is a blank page, Your Drawing Page, ready for your creativity! Each 30-minute instruction is broken down into four clock-timed steps, generally along these lines:

 1) Draw a **blueprint** made up of geometric shapes (Draw Your Blueprint).

2) Refine the blueprint to more closely match the photo ("Shape the Shapes").

3) Add shading (See the Light). The sun graphic represents the position of the light source.

4) Polish and refine the drawing (Finish Up!).

4. *Bonus Challenge.* On the final page of each chapter you'll find ideas for going beyond the first 30 minutes and creating more drawings related to the sketch you just drew. Sometimes I'll show you how to draw a related object; for example, after the 30-Minute Wine Bottle I provide instructions for drawing a wine glass. Sometimes I'll show you how to draw a similarly shaped object, and on occasion I'll teach more about a specific technique we used earlier in that chapter. And there are a few times you'll find other ways to create the same drawing. Drawing is fluid, and there's no one "right" way to accomplish your goals.

MY TOP SEVEN DRAWING TIPS!

Although you'll find plenty more lesson-specific tips in every chapter, the following ideas and techniques apply to most chapters and to most of your drawings, whether derived from this book or not. Here we go!

1. Draw Lightly

Erasing and refining make a drawing come to life. Nobody gets every line of a drawing exactly where they want it to be the first time. The techniques underlying these 30-minute lessons rely on erasing. Each drawing begins with basic shapes that are sketched quickly and almost as quickly erased and redrawn during the process. Even most of the shading is done in light layers. Make it easy on yourself and draw with a light hand.

2. Use a Smudge Shield

Protect finished parts of your drawing by placing a clean scrap of paper over them on which to rest your hand while you draw other sections. This will save you a boatload of frustration!

3. Remember: Your Paper Is Not Glued to Your Desk

It's not cheating to rotate your paper! Most people naturally find it easier to draw in one direction rather than the other; if you need to spin the paper to make it easier on yourself, do it!

4. Use the "Pencil-Measure" Hack

In many chapters you'll see the instruction to use the "pencil-measure" hack. You can *always* employ some version of this technique to determine and reproduce the **relative size** of parts of the object in your drawing. Hold up a pen or pencil, close one eye, and use it to measure the length or width of a part of the object you're drawing, noting the length or width with your finger on the appropriate spot on your pencil. You can do this whether the object is across the room, in one of the photos in this book, or on your computer screen. As you measure different parts of an object using this technique, make sure to stay the same distance away from the object; if you move toward it, it will be larger relative to your pencil and you'll have to start over.

5. Use Your Eyes to See Relative Size

Artists "see" parts of objects they draw in relation to other parts of objects they draw. Although I do suggest specific **sizes** for some of the drawings in this book, the sizes of each element in a drawing are all relative to each other. Keep that in mind as you draw. If you're drawing someone's head and torso, notice how many "heads" wide the torso is. Is the vase you're drawing three times as tall as it is wide? The pencil-measure hack will help you find the answers, as will the measuring short-cuts I provide in each chapter.

6. Make a Quick Ruler

Take a piece of scratch paper, fold it in half and half again and half again, unfold it, and *voilà*! The creases form an instant ruler—another quick way to keep the parts of the object in proportion. The measurements in drawing have little to do with an objective ruler; for example, you can use your pinky to make a ruler with pinky-sized increments, or you can measure your object in pennies.

7. I Love a Stumpy!

Blending the shading on pencil drawings can make the drawings look smooth and realistic. I usually blend shading with my finger or with a tool that's called a *blending stump*. These stumps, made of tightly rolled paper with a point at each end, cost less than a dollar apiece and are easy to find at any art supply store or online. I highly recommend you buy a pack.

But this book is all about being resourceful and using what's handy. If you don't have one, you can make your own stumpy easily! Use a folded napkin, tissue, or paper towel as your stumpy, or get a little more formal and wrap a folded soft paper around the end of a pencil (attach with a rubber band if there's one around).

You can use a stumpy on every drawing in this book! You'll find some practicing techniques in Lesson 16, 30-Minute Wine Bottle (page 101) and in Lesson 24, 30-Minute Seashell (page 149).

LET ME KNOW WHAT YOU THINK!

This book doesn't only include my art—several artist friends also contributed to parts of this book. You'll see their names listed in the Acknowledgments (page 161) and in the chapters to which they contributed. I'm thrilled to have other students and artists use this system and improve it with their own creative suggestions!

I hope you love doing these 30-minute drawings, and I especially hope you use the techniques in this book to keep creating your own. Please show me your art! Tell me how you're doing, and e-mail me your suggestions at mark@markkistler.com. And no matter what, keep drawing!

30-MINUTE BANANA

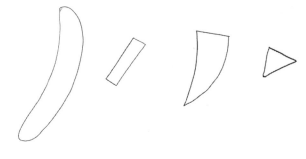

Bananas are just plain funny . . . even saying the word makes me chuckle. Whenever I draw bananas—which is quite often when I'm teaching kids how to draw—I'm reminded how much fun drawing can be and how whimsical any of us can be when we draw. My most popular drawing lesson with kids is my "Ninja Banana." I put a ninja mask and eyes on my banana sketch; the juxtaposition of the fierce fighter and the mushy banana always cracks up kids—and me. So I won't mind if you laugh too while *you* draw this funny fruit!

LOCATION

I'm drawing this banana at the Comic Con in Portland, Oregon, where I'm a guest artist. On a banana break, of course.

BANANA DRAWING TOOLS

- ▶ Pencil
- ▶ Eraser
- ▶ Paper to draw on—or use the practice page 13
- ▶ Your hand, a banana, or anything else with a curve to it

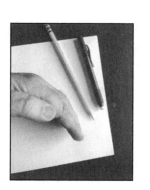

TODAY'S BANANA

Isn't this an aPEELing photo? Lucky me—I can't hear you groaning.

SHAPES IN A BANANA

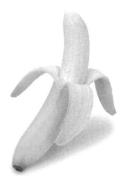

DECONSTRUCTED BANANA

Before You Begin . . .
Read these two pages.
No drawing yet!

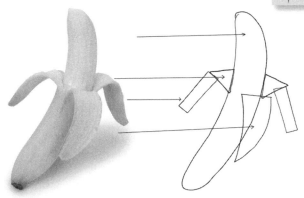

Okay, okay, I admit it—to draw a banana you start with . . . a banana shape. I call it a "curving oval" in keeping with the "draw the basic geometric shapes you see" system I use in this book, but yes, it's pretty much an oval that is shaped like a banana. You can do it! I also see triangles and rectangles in the shapes of the three peels that hang down.

30-MINUTE BANANA HACKS

Trace Your Hand Hack

If you happen to have a not-too-ripe banana within reach, you can use it to trace the curve of your banana shape. Heck, you can use anything nearby with a gentle curve (have a boomerang handy?). You could even curve your hand a little and trace that. But it's a pretty easy shape to sketch without a guide—give it a try (Figure 1)!

Holding Line Hack

Draw a **holding line** about a third down from the top of the banana. A holding line is a lightly drawn guideline (later erased) that helps you place other parts of a drawing. This visual guide will help you place the folding peels.

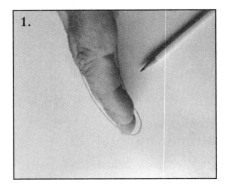

TIPS AND TECHNIQUES

Flip Tip

I find it's easier for me to draw a curve in one direction than the other. If you plan to draw the banana shape freehand, first practice some curves to see which direction flows better for you. Then flip your drawing paper or book around to ease your curve drawing. Remember: your paper is not anchored to the table!

I like to "push" the curve rather than "pull" it, moving my wrist like this (Figure 2):

2.

Folding the Peel

Shading is the key to the illusion that the banana peel is actually folded over. Shade the nooks and crannies nearest the fold the darkest, then lighten as you move away from the fold (Figure 3).

Adding the peel's edges enhances the illusion that the peel is folding over on itself (Figure 4).

3.

Measuring Shortcuts

▶ If you draw a banana as long as your thumb, it's about the width of your pinky.
▶ The exposed part of the banana is about a third of the length of the whole banana.
▶ The curving triangle for the front peel begins in the center of the banana shape.

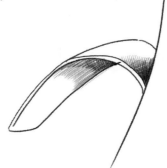

4.

DRAW THAT BANANA!

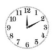

1. Draw Your Blueprint
10 minutes!

Draw lightly!

1.

▶ Draw a curving oval with a holding line about one-third down on the banana as shown (Figure 1).

2.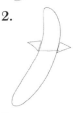

▶ Draw triangles on each side of the banana, adjacent to the holding line (Figure 2).

3.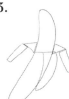

▶ Add rectangles below the side triangles and add a curving triangle (Figure 3).

2. Shape the Shapes
5 minutes!

▶ Round the edges of each hanging peel.
▶ Add a "V" shape showing the peel tear (Figure 4).
▶ Erase extra lines (Figure 5).

4.

5.

3. See the Light
10 minutes!

 Notice where the light strikes this image.

6.

▶ Shade the side opposite the light (Figure 6).
▶ Shade the darkest darks: under the folds, in nooks and crannies (Figure 7).
▶ Add a **cast shadow** darkest where the banana touches the surface (Figure 8).

7.

8.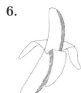

4. Finish Up!
5 minutes!

▶ Draw the stalk details and peel edges (Figure 9).
▶ Lightly shade the peel to suggest a darker yellow tone; blend with your finger (Figure 10).

9.

10.

YOUR DRAWING PAGE

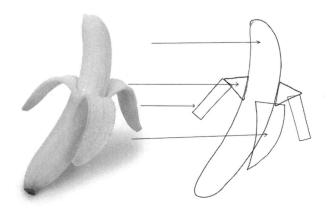

BONUS CHALLENGE: PRACTICE FOLDS

The folds in the banana peel give the drawing identity and **dimension**, the illusion of depth. This fast exercise will improve your skills at drawing folds—plus it's satisfying to quickly and easily create such an advanced-looking sketch! (Find more ways to draw folds and ribbons in Lesson 25, 30-Minute Ballet Slippers, on page 155.)

1. Draw a holding line across the middle of your page. Draw a series of connected loops on the line, as shown (Figure 1).
2. Map out where the parallel, angled lines I call "peek-a-boo" folding lines (where the material folds) will go, using dots. Each line will begin where the left or nearer edge of a bottom loop intersects the holding line. Dot those spots. Draw the first peek-a-boo line (on the far left) at about a 45-degree angle (Figure 2).
3. Draw the rest of the folding lines, top and bottom, all at the same angle as the first. Important! The folding lines at the top begin on the *far* or *right* side of each loop top (draw dots if they help) (Figure 3).
4. Draw the edges of the ribbon connecting the folding lines (Figure 4).
5. Shade the areas opposite the **light source**. Darken most of the hidden places: on the surface under the ribbons and under the folds. Erase the holding line and dots (Figure 5).

1.

2.

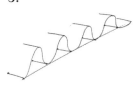

3.

4.

5.

30-MINUTE MOUTH

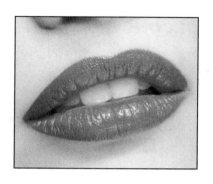

If eyes are the windows into the soul, then perhaps the mouth is our doorway to the world. Open the door and share your ideas, creativity, laughter, and joy! Mouths are fun to draw in 30 minutes; they can be completed easily within the time window and are a great way to practice drawing **contour lines** that give curved objects fullness and shape. It's hard to go wrong drawing mouths. There are 7 billion people on the planet, which means there are billions of variations in mouth shapes. No matter how your drawing turns out, it probably looks like one of them!

LOCATION
I'm drawing this at a table in my local grocery store deli.

MOUTH DRAWING TOOLS

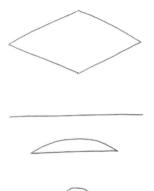

▶ Pencil
▶ Eraser
▶ Paper to draw on—or use the practice page 19
▶ Business card
▶ Penny

TODAY'S MOUTH

Smoochy bisoux to you, my friends!

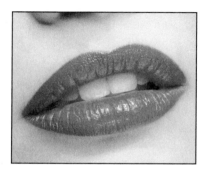

SHAPES IN A MOUTH

DECONSTRUCTED MOUTH

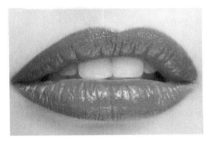

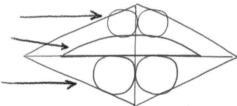

Before You Begin . . .
Read these two pages.
No drawing yet!

It took me some trial and error to find the basic shapes in this mouth. I finally realized the quickest **blueprint** is to draw a **bisected** diamond (a diamond divided down the middle). Circles at the fullest points of the top and bottom lips will help me shape and contour the lips later. The space between the lips is a semicircle (created by drawing one curved line). Notice that the teeth aren't part of my blueprint—they're important to the drawing, but I don't need to sketch them in at the beginning. As ever, the goal of the basic shape blueprint is to turn intimidating blank paper into an inspirational canvas!

30-MINUTE MOUTH HACKS

Business Card Holding Lines

Two intersecting lines provide a visual **placement** key for the mouth. To hack:

1. Lightly trace the long edge of a standard business card. Fold the business card in half; use it to find and dot the line's center (Figure 1).
2. Unfold the card, refold it length-wise, unfold it again, and then dot along the crease (Figure 2).
3. To draw the short vertical line: Match the dot on the card to the dot on the long line and lightly trace the short end of the business card—*voilà*! (Figure 2). Connect the end of these **holding lines** to draw your diamond (Figure 3).

Penny Hack

Draw the **holding circles** on the lower lip by tracing a penny. (Draw the smaller circles on the upper lip freehand.)

People often draw lips too thin. Holding circles will help you avoid this (Figure 4).

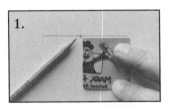

1.

2.

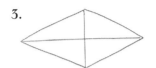

3.

4.

MEASURING SHORTCUTS

▶ The horizontal holding line is about twice as long as the vertical line intersecting it.
▶ The circles on the top lip are about three-fourths as big as the penny-traced circles.

 ▶ The bottom-lip circles rest in the corners of the diamond holding lines. They might extend a little below the bottom of the diamond.
 ▶ The top circles rest on the curved line that forms the mouth-opening semicircle.
 ▶ The top circles extend a little above the top lines of the diamond.

Teeth Placement and Size

▶ The two front teeth straddle the vertical holding line.
▶ The two front teeth are each about the width of a top holding circle and smaller than the width of a bottom holding circle.

TIPS AND TECHNIQUES

Before you turn on the clock, practice drawing the contour lines on the upper and lower lips. **Contour lines** are curving lines that follow the shape of an object to create **dimension**.

 See the cone shapes on the blueprint? Use these as a guide for drawing the contour lines that give the lips fullness and shape (Figures 5 and 6).

 This drawing's contour lines curve in to match the circles at the lower lip's center (Figures 7 and 8).

5.

6.

7.

8.

DRAW THAT MOUTH!

 1. Draw Your Blueprint

5 minutes!

Draw lightly!

1.

▶ Draw a diamond shape using the holding lines hack (see page 16) (Figure 1).

2.

▶ Draw the semicircle for the shape between the lips (Figure 2).

3.

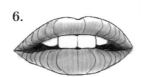

▶ Draw circles nestled next to the holding lines as shown (Figure 3).

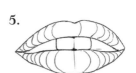 **2. Shape the Shapes**

10 minutes!

▶ Draw the two front teeth (see measuring shortcuts, page 17).

4.

▶ Erase the holding lines and the points between the circles (Figure 4).

5.

▶ Outline the softened shape of the mouth (Figure 5).

▶ Sketch in some **contour lines**, using the circles as your guide (Figure 5).

▶ Erase the circles and other extra lines (Figure 5).

▶ Draw the smaller teeth.

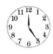 **3. See the Light**

10 minutes!

Notice where the light strikes this image.

▶ Shade the inside of the mouth under the teeth (Figure 6).

▶ Use your finger (or a stumpy, page 6) to pull **shading** into the lips. Don't worry if it smears (Figure 6).

6.

▶ Darken the parts of the drawing that are farthest from the **light source**. Erase the bottom lip **highlights** (Figure 7).

7.

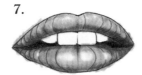

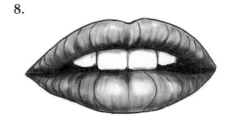 **4. Finish Up!**

5 minutes!

▶ Erase any smudges, and lightly erase a few highlights from the top lip.

▶ Add more **contour lines**.

▶ Darken and define the outer edges (Figure 8).

8.

YOUR
DRAWING
PAGE

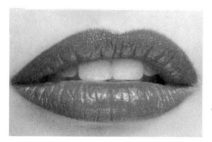

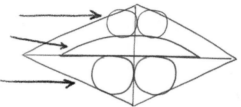

BONUS CHALLENGE: CONTOUR LINES ON CYLINDERS

The **contour lines** that give the lips fullness are worth practicing! They're fun to draw and a great way to make all kinds of tubular drawings look realistic. Let's practice giving **dimension** to cylinders.

TUBE ANGLED AWAY FROM YOU

Contour lines don't just show depth; they can also help place objects in space. Increasingly smaller and curvier contour lines create the illusion of distance. (What's actually happening: if you imagine the lines are the edge of a circle, as the circles get smaller going backward, their edges look curvier. Figure 1.)

1. Draw a line angled slightly down (the tube's bottom) (Figure 2).
2. Draw a circle on the left side as shown (the tube's front opening) (Figure 2).
3. Draw the top edge of the tube, angled down as shown (Figure 3).
4. Draw a semicircle as the back end of the tube, making the semicircle at the back end curvier than the oval of the opening (Figure 3).
5. Draw contour lines, matching the round shape of the front and progressively getting smaller and curvier to match the circle shape at the back (Figure 4).
6. Emphasize the shape with shorter contour lines along the bottom edge, opposite the light source (Figure 4).

1.

2.

3.

4.

Once you've practiced a few cylinders, try drawing this donut!

30-MINUTE CHAIR

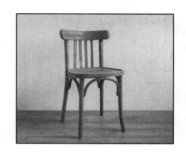

While creating this lesson I kept thinking of one of my favorite movies, the 2002 version of *The Count of Monte Cristo* starring Jim Caviezel. Caviezel played Edmund Dante, who is imprisoned in a dungeon for twelve years with not even a chair to sit on. When Dante digs his way into another prisoner's cell, he sees an old wooden chair, sits, and is overwhelmed by its comfort. A great scene in the movie and a valid point: What would our days be like without chairs?

LOCATION

I'm drawing this in my drawing studio in my house—and I'm sitting in a chair, of course.

CHAIR DRAWING TOOLS

▶ Pencil
▶ Eraser
▶ Paper to draw on—or use the practice page 25
▶ Scrap piece of paper
▶ Your pinky finger

TODAY'S CHAIR

Take that, standing-desk-at-work movement!

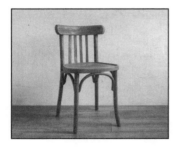

SHAPES IN A CHAIR

DECONSTRUCTED CHAIR

Before You Begin . . .
Read these two pages.
No drawing yet!

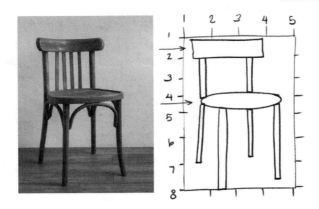

The basic shapes in the chair are pretty easy to see: an oval for the seat and rectangles for everything else—the legs, the back, and the stiles. The biggest challenges: How do you draw those legs in proportion to one another? My trick: I put the chair into its own **holding box** so the legs don't fly off the page. I create the box using either a ruler or a very rough "instant ruler" (see below). Important elements of this drawing: the front legs are longer than the back legs to show **dimension**. I also really like the way the under **shadows** and **cast shadows** make the whole drawing pop off the page and look three dimensional. (That comes later.)

30-MINUTE CHAIR HACKS

The Instant Ruler

If you don't have a ruler handy, draw a series of eight or so pinky-wide lines along the straight edge of a piece of scrap paper as shown (Figure 1).
 Number the lines (Figure 2).

The Chair Inside the Box

A sketched holding box keeps complicated drawings from getting all out of proportion. Use your instant ruler to draw a rectangle, making the sides twice as long as the top. Create a little drawing grid for yourself; draw and number the lines on the rectangle corresponding to your pinky lines on the instant ruler. This will help you determine the lengths of all the chair parts relative to each other (this measurement system isn't meant to be perfectly accurate) (Figure 3).

MEASURING SHORTCUTS

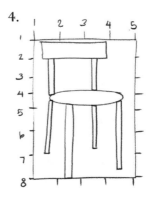

▶ This holding box is about seven pinkies tall and four pinkies wide.

▶ The oval for the chair seat begins about three pinkies from the top of the holding box, at number four on this drawing.

▶ The chair back is a little less than a third of the height of the longest chair leg.

▶ The front left leg is longest and lowest in your drawing.

▶ The back right leg is shortest and highest in your drawing.

▶ See diagram for where the parts of the drawing fall within your holding box (Figure 4).

Notice This: *The chair legs are not actually parallel. You'll be splaying them a little when you shape the shapes.*

TIPS AND TECHNIQUES

Horizon Line

Where the wall meets the floor in the photo is called a **horizon line**. Drawing a simple horizontal line in our 30-minute version gives your viewer a strong reference as to where the chair is sitting on the ground.

Lines and Shading on the Seat

Transforming your oval into a realistic seat takes a few steps and an awareness of where the light hits the seat. Some tips:

1. When "shaping the shapes" add a line to give the illusion of thickness (Figure 5).

2. When first **shading**, add shadows away from the **light source** (on the left side) (Figure 6).

3. In the final drawing phase add both the lip of the chair seat and the shadow under the lip (Figure 7).

DRAW THAT CHAIR!

1. Draw Your Blueprint

10 minutes!

Draw lightly!

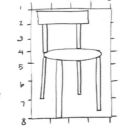

1.

- ▶ Draw a rectangle in which to draw your chair (use the "instant ruler" hack, page 22, if you wish).
- ▶ Draw an oval for the seat.
- ▶ Draw the front legs (front left leg is longest and lowest on the page).
- ▶ Draw the back legs (back right leg is shortest and highest).
- ▶ Draw the chair back and two main supports (Figure 1).

2. Shape the Shapes

5 minutes!

- ▶ Draw lines to show the edges of the seat and back. Angle and slightly curve the legs (Figure 2).
- ▶ Draw four back stiles (supports) and three curved under-seat supports (Figure 3).
- ▶ Round off corners and add the **horizon line** (Figure 4).

2.

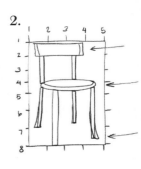

3.

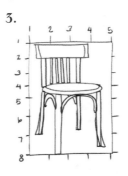

4.

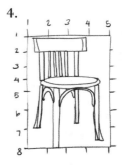

3. See the Light

10 minutes!

Notice where the light strikes this image.

5.

- ▶ Erase your original **blueprint**.
- ▶ Shade everywhere opposite the light source: the left side of each leg, each support, and each edge (Figure 5).
- ▶ Add **cast shadows** below each leg (Figure 6).

6.

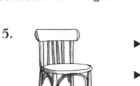

4. Finish Up!

5 minutes!

- ▶ Darken the darkest spots—under the seat, under the seat back, and on the curved seat supports.
- ▶ Shade the seat back to add **dimension**.
- ▶ Add the chair lip and shadows.
- ▶ Take a seat (Figure 7)!

7.

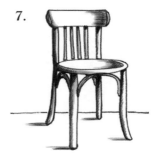

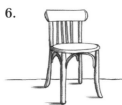

YOUR
DRAWING
PAGE

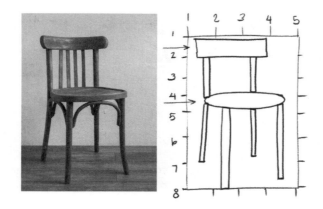

BONUS CHALLENGE:
A COMFY CHAIR

The functional design of furniture has always fascinated me. Whether Renaissance or colonial or modern in style, all furniture must be conceived and sketched before anything else happens. Let's have some fun and play furniture designer for a day. Take the basic oval shape we used for the chair's seat in this chapter and create a new chair from there.

1. Draw an oval (Figure 1).
2. Draw lines extending down from the sides of the oval, and add a curved bottom as shown (Figure 2).
3. Hey, it looks like the original oval has turned into the top of this chair! Let's give folks somewhere to sit and an opening in the chair arms. Add a curved dotted line duplicating the curve of the bottom and a line down from the middle of the top oval to the dotted line (Figure 3).
4. Give **dimension** to the chair by adding edges (Figure 4).
5. Give folks a clearer idea of where to sit. Now erase the extra lines (Figure 5).
6. Shade away from the light source, add your **horizon line**, and OOOOH! That's a comfy chair (Figure 6)!

1.

2.

3.
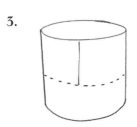

4.
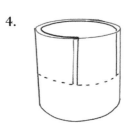

5.
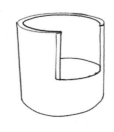

6.
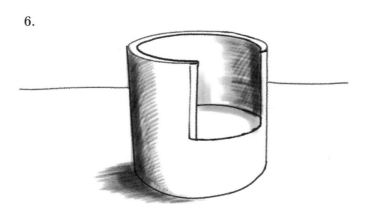

30-MINUTE PENGUIN

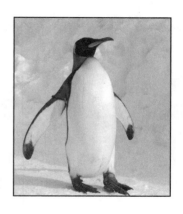

What a creature! Proud and playful, dignified and goofy. I could watch penguins for hours. In fact, I *have* been watching them for hours, chuckling at their playful antics, completely forgetting that I came to the aquarium to draw penguins, not stare at them. Darn! I now have 15 minutes to put together my 30-minute lesson before the aquarium closes. Good thing I came here for inspiration and not for my model; this chapter's 30-minute drawing is based on a photo (I can count on my photo penguin to stand still for half an hour). Communicating the idiosyncratic penguin posture on paper quickly is a fun challenge!

LOCATION

I'm drawing this (mostly) at the Moody Gardens Aquarium Pyramid on Galveston Island, Texas.

PENGUIN DRAWING TOOLS

- ▶ Pencil
- ▶ Eraser
- ▶ Paper to draw on—or use the practice page 31
- ▶ Your thumb
- ▶ Your pinky finger
- ▶ Stumpy

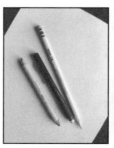

TODAY'S PENGUIN

The emperor!

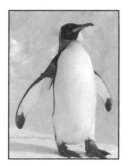

SHAPES IN A PENGUIN

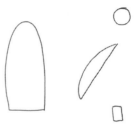

DECONSTRUCTED PENGUIN

Before You Begin . . .
Read these two pages.
No drawing yet!

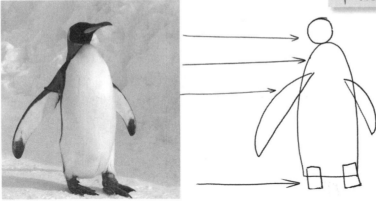

Drawing the penguin is less complicated when you think of this dignified guy as a group of familiar geometric shapes. I see his body as a big arch, his head as a circle that sits atop the arch and over to one side, his wings as half-ovals, and his legs as small rectangles. When I break an object into basic shapes, I don't worry about the details—like the penguin's toes or beak. It's much easier to draw details after you've mapped out the **blueprint**. Once you have the basics drawn you can see where those details fit relative to the shapes you've already placed. Good-bye, drawing anxiety!

30-MINUTE PENGUIN HACKS

Thumb Body

Thumbody—me—loves penguins! And bad puns. Trace your thumb to create the arch shape of the penguin's body (Figure 1).

Pinky Wings

Trace the side of your pinky to sketch in the half-oval-shaped wings.

Beak Hack

The beak isn't hard to draw, but its **size** and **placement** can be tricky. To hack it:

1. Use your pinky to place an **anchor dot** before drawing the beak part outside the head (Figures 2 and 3).
2. Extend the lines to sketch in the beak part that **overlaps** the head (Figure 4).

Make sure to slant his beak proudly up to the sky!

MEASURING SHORTCUTS

▶ The penguin body is more than *five* penguin heads tall!

▶ The penguin head is about half as wide as his body.

▶ If the head is one pinky wide:

 ▸ The beak extends one pinky out from the head.

 ▸ The front leg is about one pinky tall; the back is a little less.

 ▸ The distance between the outside edge of the penguin's longer wing and the penguin's body is just about as long as the body is wide.

▶ The outside line for each leg extends down from the outside line of each side of his body.

TIPS AND TECHNIQUES

Slanted Toes Make the Penguin 3-D

Notice how the toes in the photo appear to slant down? That's partly because the penguin is on a little hill and partly because things that are closer to us look lower and bigger than things that are far away (Figure 5).

Gently Shade with a Stumpy

The subtle **shadows** on the penguin's mostly white body create the illusion of a hefty living seabird. I love using a stumpy, which you can make yourself (see page 6) to blend **shading** and create understated shadows—or you can use your finger.

First, draw the darkest shadows in the areas farthest from the **light source**—on the left side of the body and underneath the bottom edge of each wing (Figure 6).

To create the lighter shadows, use your stumpy or finger to spread and blend the pencil lead already on your drawing (Figure 7).

Practice this technique a few times on the side of your drawing page before starting your 30-minute penguin (Figure 8).

5.

6.

7.

8.

DRAW THAT PENGUIN!

 1. Draw Your Blueprint

5 minutes!

Draw lightly! Hack if you like:

- Draw a thumb-shaped arch
- Draw a circle for the head
- Draw half-ovals for the wings
- Draw two rectangles for the legs (Figure 1).

1.

 2. Shape the Shapes

10 minutes!

- Draw the neck and beak (see hack, page 28) (Figure 2).
- Draw three toes on each foot, slanted down (see hack, page 29) (Figure 2).
- Modify the wings to more closely resemble the photo. I angled in the top of the larger wing and softened the wing tips (Figure 3).
- Erase the extra lines of the **blueprint** (Figure 4).

2.

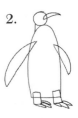

3.

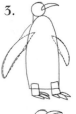

4.

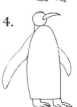

 3. See the Light

10 minutes!

5.

6.

7.

- Darken the black and gray patches (no shading yet) (Figure 5).
- Determine where the light strikes the image.
- Shade the sections hidden from the light—the left side of the body, under the neck, and the lower parts of the wings and body (Figure 6).
- Add the **cast shadow** extending behind each foot (Figure 6).
- Blend and extend the shadows with your finger or stumpy (Figure 7).

4. Finish Up!

5 minutes!

- Darken the darkest spots to add definition:
 - between the toes (see the webbed feet?)
 - along the edges
 - between his body and his neck and wing on the left side
 - under his belly and feet
 - along the top of his beak.
- Sketch or stumpy in a cloudy sky.
- Erase any smudges (Figure 8).

8.

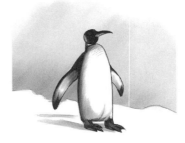

And ... *grin just thinking about penguins. Then remember climate change, drop this book, and adopt an emperor penguin through the World Wildlife Fund like I did. (His name is Pepe!)*

Learn more at https://gifts.worldwildlife.org/gift-center /gifts/species-adoptions/emperor-penguin.aspx.

YOUR DRAWING PAGE

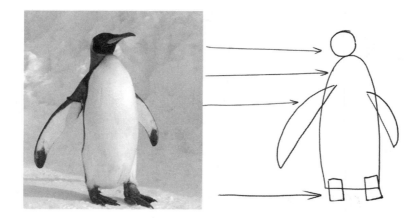

BONUS CHALLENGE: ANOTHER PENGUIN

Now that we know how to break a penguin down into basic shapes, let's draw another one. This time we'll have him serenely floating along on his own patch of ice. The penguin in this drawing is facing farther away from us than the 30-minute penguin and we see more of his back. This angle changes the position of his head so it's above the middle of his body.

1. Draw the basic arch shape with a small circle for the head. Remember the ratio of head to body in a penguin is surprisingly high. Penguin bodies are usually at least five penguin heads tall (Figure 1).
2. Add a beak, a long oval for the ice, and a **blueprint** of his reflection below the ice (Figure 2).
3. Refine the shapes.
4. Color in dark wings on the bird and his reflection. Add details to the ice and water, and pile up snow to hide his feet. Add thickness to the ice and swirls to suggest ripples in the water (Figure 3).
5. Place your light source on the page, and shade and blend accordingly (Figure 4).

1.

2.

3.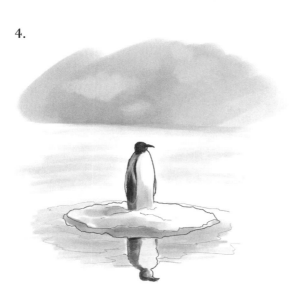

4.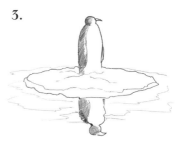

30-MINUTE TOMATOES IN A BASKET

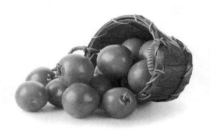

Years ago my buddies Eric, Henning, and Candice and I bartered for part of our stay in a beautiful villa in Soloma, Spain, by agreeing to water the owners' two acres of tomatoes—every day for a month! We ate tomatoes at every meal: tomatoes for breakfast, lunch, and dinner and even tomato tapas. Did we get tired of tomatoes? No way! The sun-ripened tomatoes—in the middle of a gorgeous, 20-acre vineyard—just enhanced the authenticity of our travel experience. I'll never forget it.

My goal in this 30-minute sketch is to reproduce the *feel* and *appeal* of the tomatoes; I'm not going to try to get every single tomato in the right place—and nor should you.

LOCATION

I'm drawing this at Starbucks in New Jersey.

TOMATOES IN A BASKET DRAWING TOOLS

- ▶ Pencil
- ▶ Eraser
- ▶ Paper to draw on—or use the practice page 37
- ▶ Bottom of a coffee cup
- ▶ Your thumb
- ▶ Credit card

TODAY'S TOMATOES

I have a feeling you're going to love drawing this bountiful basket!

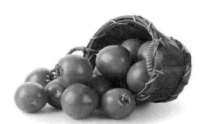

SHAPES IN TOMATOES IN A BASKET

DECONSTRUCTED TOMATOES IN A BASKET

Before You Begin . . .
Read these two pages.
No drawing yet!

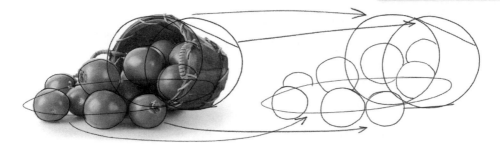

I first notice two big circles and an oval in this image. The lovely tomatoes spilling out of the basket are rough little circles, and a few key semicircles and straight lines finish out the basic shape **blueprint**. But it's a little tricky, as these shapes all **overlap**. The large oval extending beyond the basket opening helps place the tomatoes' circles. The large oval helps place the smaller circles.

30-MINUTE TOMATOES IN A BASKET HACKS

Big Circle Hack

Use the top or bottom of your coffee cup (or any small glass or mug) to trace the overlapping big circles that form the basket. Later trace the same cup to draw the semicircles on the top and bottom basket ridges when polishing the drawing (Figure 1).

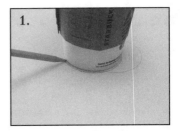

Thumb Oval Hack

Trace your thumb (Figure 2), then flip the paper and trace your thumb again to make that nice oval shape formed by the tomatoes spilling out of the basket.

Straight Lines Hack

Grab anything with a straight edge to trace the lines—I used a credit card.

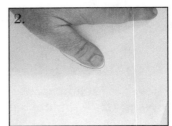

MEASURING SHORTCUTS

▶ The oval shape is about twice as wide as the big circles.
▶ The second big circle intersects the first near the middle of the first's bottom.
▶ The biggest tomato is about half the width of the big circle.

TOMATOES IN A BASKET: BLUEPRINT BREAKDOWN

I draw the **blueprint** in a few stages because the basic shapes **overlap**. Familiarize yourself with these steps before you turn on the clock.

Stage One

Drawing the big circles, the oval, and the connecting lines

▶ Trace the cup to draw the two big overlapping circles (Figure 3).

▶ Draw two straight lines to indicate the basket body. The line on the top angles *down* more steeply than the line on the bottom angles *up* (Figure 4).

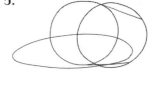

▶ Lightly draw the flat oval where shown, overlapping both circles. This will help you place the tomatoes on the page. This oval will be erased soon (Figure 5).

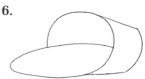

Erasing the extra parts of the circles
Erase everything that isn't "basket" from the two circles—everything above and below the straight lines and the overlapping part of the circles (Figure 6).

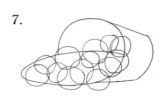

Stage Two

Tomato time! Drawing overlapping small circles for tomatoes
Start with the tomato/circle closest to you—it's a little bigger than the ones farther away. Overlap the circles! Draw them fast; don't worry about perfect circles or where they are. Don't try to draw every tomato (Figure 7).

The Great Erase: Tips

All right, brave drawing friends! When it's time to erase the extra lines in the overlaping circles, here's how (Figures 8 and 9).

1. Start with the biggest tomato/circle (the one you want to be in the front). Erase all the lines *inside* that circle.
2. Look for the tomato *behind* the one you just erased but *in front* of all the others. Erase the extra lines inside that one.

DRAW THAT BASKET!

1. Draw Your Blueprint

10 minutes!

Draw lightly!

▶ **Stage One (see page 35):** Draw the basic shapes—the two big circles, the big oval, and the angled lines.

▶ Erase the extra lines.

1.

▶ **Stage Two (see page 35):** Don't think too hard—draw lots of overlapping small circles for the tomatoes. Make the ones closer to you a little bigger (Figure 1).

▶ Done! You'll use the semicircle shape when you get to the details.

2. The Great Erase

5 minutes!

▶ Erase that oval.

▶ Find the tomato in front and erase all the lines inside.

▶ Continue to erase extra lines (see page 35) (Figure 2).

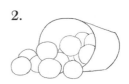

2.

3. See the Light

10 minutes!

Notice where the light strikes this image.

3.

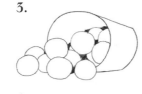

▶ Shade in the darkest nooks and crannies you see. This will make your drawing pop (Figure 3).

4.

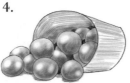

▶ Notice the great **shadows** underneath each tomato and in the basket? Add them to your drawing. Cover the rest of your drawing with light **shading** everywhere.

▶ Blend the shading on the tomatoes with your finger to make them look smoother than the basket.

▶ Pull out **highlights** with your eraser (Figure 4).

4. Finish Up!

5 minutes!

▶ Draw semicircles for the handles (Figure 5).

5.

▶ Add the crisscrosses on the basket, some squiggles for tomato stems, and more semicircles to indicate the top and bottom of the basket (Figure 6). (My lines are extra dark so you can see.)

6.

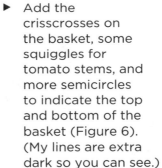

▶ Polish and complete!

▷ Darken the darkest spots and edges.

▷ Erase any extra lines (Figure 7).

7.

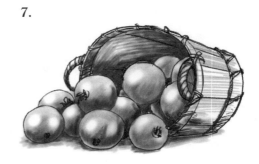

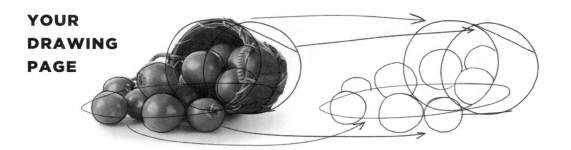

BONUS CHALLENGE: REALISTIC SPHERES

I keep coming back to this drawing—those round shapes and fun shading are so enjoyable to draw. Let's explore the shading of spheres a little further.

In this chapter we employed some simple shading to quickly create the illusion that the circles are three dimensional. When you have a little more time, practice the simple steps below to perfect the art of making round objects appear realistic.

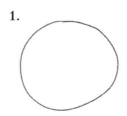

1. Start with your basic shape—a circle (Figure 1).
2. Determine the direction of the **light source**. Look at the drawing of the tomatoes—see the brightest spots on the tomatoes? I call these the **hot spots**. Imagine where the light must be coming from in order to make these spots jump out. In this chapter's photo the light is coming from above and a little to the left of center.

Place an X where you see the light hitting the object most intensely—on the hot spot.

Now, darken the edge farthest from the light source. Don't be afraid to make it very dark (Figure 2).

> Be consistent in where the light is shining on the object you're drawing. You may think that's obvious, but I've seen many drawings where the shadow is drawn back toward the light. I've made that mistake myself!

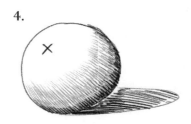

3. Add a **cast shadow** to anchor the shape to the ground. This shadow is the shape under and to the side of the object that is cast away—like a fishing line—in the opposite direction from the light source. The shape of the shadow is a squished or distorted version of the object you're drawing. In this case the circle, when flattened, becomes an oval (Figure 3).
4. Add the midtone shading. Start at the darkest areas—on the edge of the circle that's farthest away from the light. Shade toward the lightest spot, in decreasing degrees of darkness, as you move toward that hot spot (Figure 4).
5. Use your finger to smooth out the values from dark to light. Darken up the darkest shadows and edges to define the shape in space. Erase the "X" in your hot spot (Figure 5).

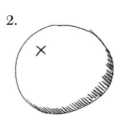

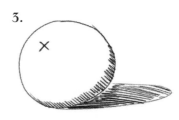

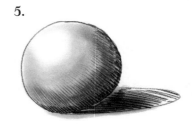

1.

2.

3.

4.

5.

30-MINUTE BOOT

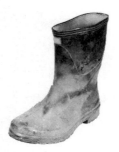

Guest artist Siera Pritikin used the 30-minute method to create this fun lesson for you and to draw all the drawings in the lesson itself (I drew the Bonus Challenge section). I am so grateful she took the time to walk in my shoes for a chapter (get it? *boot* chapter?). Siera draws amazing portraits and does some cartooning as well. "I love this 30-minute system," she told me. "I already use something like it to map out my realistic drawings, but this super-practical method really streamlines the process."

LOCATION
Siera drew this in her family room.

BOOT DRAWING TOOLS

- Pencil
- Eraser
- Paper to draw on—or use the practice page 43
- Quarter

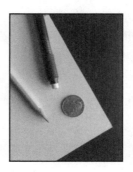

TODAY'S BOOT

Bootiful!

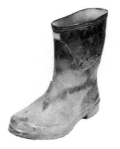

SHAPES IN A BOOT

DECONSTRUCTED BOOT

Before You Begin . . .
Read these two pages.
No drawing yet!

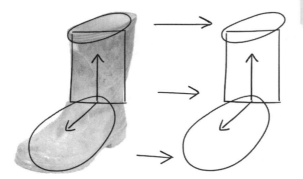

Siera suggested a few different combinations of geometric shapes in this boot. We decided to go with an oval for the foot, an oval for the opening, and a rectangle for the rest, as it's straightforward. Check out the Bonus Challenge on page 44 for more options! The trickiest parts of getting this **blueprint** on the page are (1) figuring out how to angle the foot of the boot, and (2) determining the **relative size** of all the shapes. Siera used a clock face as a visual guide for the foot angle. (Maybe she was subconsciously inspired by the theme of this book!) She recommends measuring the other boot parts in units of "boot openings," or you can use a quarter as a hack.

Boot Terminology

Deconstructing this drawing turned into an education. We learned what the parts of a boot are officially called so we could reference them while drawing. We hoped there was a fancy name for the hole at the top where you put your foot in, but that's the only nameless part. We name it, cleverly, "boot opening." And, of course, I call the entire bottom of the boot the "foot." Here's what else is what:

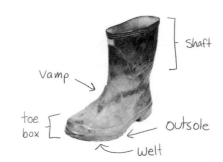

30-MINUTE BOOT HACKS

Clock Face Angle

The foot of the boot is angled relative to the boot's shaft. Think of these positions like the hands of a clock. One hand (the shaft) points to the 12, and the other (the foot) is between the 7 and the 8. You can even sketch a clock on the side of your page to look at as you draw the matching angle.

1.

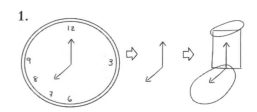

Draw the basic geometric shapes (the oval and the rectangle) right over the clock hands. The hands dictate both the **placement** of the shapes as well as their sizes because the hands go right through the middle of the bottom oval and the middle of the rectangle (Figure 1).

Boot Openings and Quarters: It's All Relative

Drawing relies on getting proportions right, so that the relative size of each part match. Here are a couple of ways to do this:

- Use the boot opening as a unit of measurement. The shaft of the boot is just a little longer than one boot opening, and the foot is just a little shorter than two boot openings (Figure 2).
- Or use the width of a quarter as the length of the boot opening. Use the quarter again to measure the shaft and foot of the boot. The proportions will be the same—the shaft is about as long as the quarter; the foot a little less than the length of two quarters.

MEASURING SHORTCUTS

- The foot is almost twice as long as the shaft is tall.
- The width of the top opening is about the same as the width across the widest part of the foot.

TIPS AND TECHNIQUES

Scuff or Shadow?

Notice the diamond-shaped mark on the front of the boot and the darker shades on the top half? They're not **shadows**; they're scuffs and discolorations and designs. How to tell the difference? Determine the **light source** and use logic. The **highlights** on the toe box and inside the boot opening tell us the light is coming from the front. It doesn't make sense for the dark scuffs facing the light to be shadows (Figure 3).

Drawing the Scuffs and Shadows

Draw the scuffs differently from the shadows to create a realistic image. Siera used **hatching** for the scuff marks and blended **shading** for the areas in shadow. Hatching is a shading or toning technique created by drawing closely spaced parallel lines. You can further increase variations in tone by using **cross-hatching**, which is drawing layers of parallel lines in a different direction over your first lines (Figure 4).

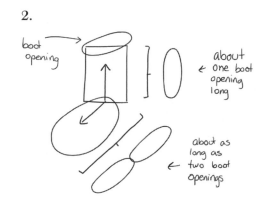

2.

boot opening

about one boot opening long

about as long as two boot openings

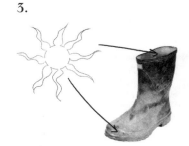

3.

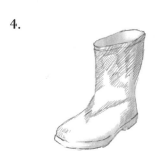

4.

DRAW THAT BOOT!

1. Draw Your Blueprint
5 minutes!

Draw lightly!

1.

- ▶ Use the clock and measuring hacks (page 40) if you like.
- ▶ Draw an oval for the opening.
- ▶ Draw a rectangle for the shaft.
- ▶ Draw a big oval for the foot. (Figure 1)

2. Shape the Shapes
15 minutes!

2.
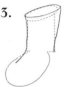

- ▶ Erase the extra lines inside the boot, including the rectangle top (Figure 2).
- ▶ Refine the opening to match the curve in the photo (Figure 3).

3.

- ▶ Draw two lines to narrow the shaft and the vamp (Figure 3).
- ▶ Add a double line for the welt, slightly refining the shape of the oval bottom (Figure 4).

4.

- ▶ Draw a line matching the shape of the welt for the toe box (Figure 4).
- ▶ Define the heel (Figure 4).
- ▶ Erase original lines (Figure 5).
- ▶ **Hatch** in scuffs and discolorations (Figure 5).

5.
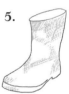

3. See the Light
5 minutes!

Notice where the light strikes this image.

6.
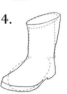

- ▶ Shade the large areas:
 - ▶ The back edge and top of the shaft
 - ▶ Inside the front of the opening
- ▶ Blend the shaded areas.
- ▶ Darken the front welt, the opening edges, and in front of the heel.
- ▶ Add a **cast shadow** (Figure 6).

4. Finish Up!
5 minutes!

- ▶ Erase the highlight on the toe if you've smudged there.
- ▶ Play! Add suggestions of design details, including the front tag.
- ▶ Erase any smudges and darken the darkest darks (Figure 7).

7.
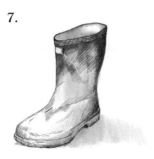

YOUR
DRAWING
PAGE

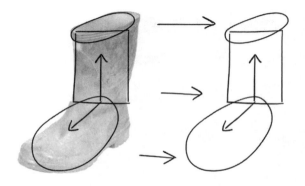

BONUS CHALLENGE: BOOT BUILDING BLOCKS

As you probably know by now, learning to "see" basic geometric shapes is a means to quickly creating a **blueprint** for anything you might want to draw. For every object in this book I suggest places to start. But there isn't really any "one" right way to draw a boot—or any object! Today's practice: find several more ways to build your deconstructed blueprint for this boot. Here are a few examples.

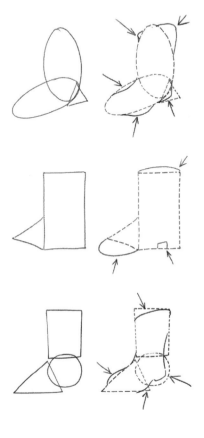

30-MINUTE CLOUDS

Magnificent image, right? I'm crazy about clouds: ever-changing, always amazing. For this lesson we'll be drawing clouds from a photo, obviously, but clouds in nature are ideal subjects for 30-minute sketches. You have to draw quickly; they constantly move! Draw clouds loosely with a light and creative touch. That's not only because they're temporary but also because, by nature's design, clouds are puffy, endlessly varied, and random. No room for perfectionism when drawing clouds, but if you evoke the *feel* of clouds, your drawing *is* perfect.

LOCATION

I'm drawing this in Albuquerque on the sky deck of the small adobe house I've rented.

CLOUDS DRAWING TOOLS

- ▶ Pencil
- ▶ Eraser
- ▶ Paper to draw on—or use the practice page 49
- ▶ Keurig K-Cup coffee pod
- ▶ Dime
- ▶ Nickel

TODAY'S CLOUD

Puffy awesomeness!

SHAPES IN A CLOUD

DECONSTRUCTED CLOUDS

Before You Begin . . .
Read these two pages.
No drawing yet!

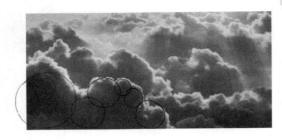

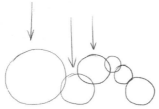

I see many circles in the cloud billows in this image, especially in the largest group of clouds toward the front. So I get those circles drawn first and use them to map out the shape of the first group of clouds. I then draw the other cloud layers relative to that first group. I don't need to use the circles to plot the shapes of the other cloud layers; I can see where to draw them using that first layer as my guide. I also don't try to replicate this photo exactly; instead, I aim for **planned randomness** to mimic nature's own design, knowing that if I vary the sizes and shapes of the clouds, they'll end up looking realistic.

30-MINUTE CLOUD HACKS

K-Cup and Change

If you like, hack the bigger circle of your **blueprint** by tracing something round like a K-Cup coffee pod and then the little circles by tracing nickels and dimes.

TIPS AND TECHNIQUES

Draw the Cloud Puffs Freehand

Draw the puffy shapes of the clouds' edges freehand. To do so:

1.

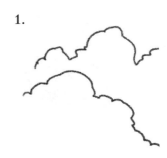

▶ Keep your drawing hand loose to draw these soft billows.
▶ Wobble your hand up and down, alternating pace and rhythm to create a variety of sizes and spacing.
▶ Remember: variety is essential (Figure 1)!

Cloud Shading

While the shapes in clouds are distinctive, it's **shading** that gives them substance and grandeur on the page. Notice how the edges of each cloud layer are rimmed with white, while the areas in shadow are rich with a variety of tones. Here's a detailed breakdown of the shading steps in your 30-minute clouds.

1. Begin by shading *behind* the front clouds wherever clouds **overlap** one another. See how this instantly pops out the cloud in front (Figure 2)?
2. Add soft tone to the front layer (Figure 3).
3. Add more shading in a variety of tones so all the clouds have some tone (except for the cloud edges—leave them white where possible). The light source in the photo is above and a bit to the right, which means the parts of the clouds closest to the light are lighter while the areas of those parts in shadow appear even darker.
4. Now darken the darkest spots—don't hold back! Define the back of the edges left white by adding even darker shading behind each clump. Darken the nooks and crannies wherever you see them (Figure 4).
5. Blending the shading is another trick that makes your clouds look more realistic. You can use your finger or a stumpy (see page 6) (Figure 5).

2.

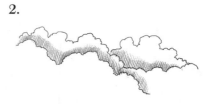

3.

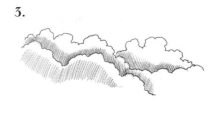

4.

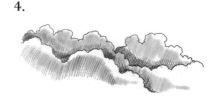

5.

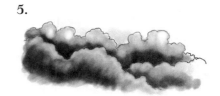

DRAW THOSE CLOUDS!

 ## 1. Draw Your Blueprint

5 minutes!

Draw lightly!

▶ Draw a circle near the lower left side of your page (Figure 1).

▶ Draw two nickel-sized circles adjacent to the first circle (Figure 2).

▶ Draw three more circles—two small and one larger (Figure 3). Place each in relation to the previously drawn circle.

1.

2.

3.

 ## 2. Shape the Shapes

10 minutes!

▶ Following the top line of your **blueprint**, draw a matching line of randomly sized bumps and lumps for the top of the front row of clouds (Figure 4).

▶ Erase the original blueprint.

▶ Draw, freehand, the outside edge of the cloud clump behind your first clump (Figure 5).

▶ Draw, freehand, the outside edges of the final two cloud clumps, placed relative to the first two clumps (Figure 6).

4.

5.

6.

 ## 3. See the Light

10 minutes!

Notice where the light strikes this image.

▶ Shade *behind* the top edge of each cloud clump.

▶ Add a variety of tones everywhere except the lightest lights (see tips, page 47) (Figure 7).

▶ Darken the darkest nooks and crannies.

▶ Begin blending (Figure 8).

7.

8.

 ## 4. Finish Up!

5 minutes!

▶ Erase top edge highlights (if needed) and smudges.

▶ If you like, add more cloud clumps and layers.

▶ Darken the darkest spots to give your drawing more **dimension**.

▶ Finish blending (Figure 9).

9.

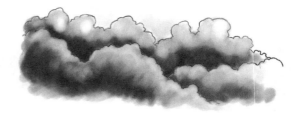

YOUR
DRAWING
PAGE

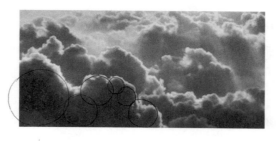

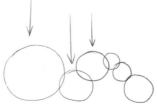

BONUS CHALLENGE:
3-D PUFFY CLOUD LETTERING

I enjoy drawing clouds and puffy texture so much! If you can't get enough of clouds either, there's also a bonus cloud drawing lesson on page 141 of my book *You Can Draw in 30 Days!* I also teach a *lot* of cloud texture drawings in my book *Drawing in 3-D with Mark Kistler*, from cloud houses to "vroom" action clouds, jet clouds to space shuttle launch clouds, overflowing washing machine bubbles to twisting tornados, and more! However, I have to say my favorite use of this cloud clump technique is with cloud lettering, which I feature throughout *Drawing in 3-D.* Let's pick a letter or two and draw a 3-D puffy cloud letter. This will amaze your colleagues at work when you doodle these on your memo notes!

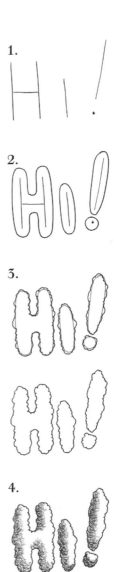

1. Very lightly draw the word "Hi!" Space the letters and exclamation point out a lot—you'll soon see why (Figure 1).
2. Draw a round fat outline around each letter (Figure 2).
3. Erase the inside lines. Using a lot of hand wiggling and **planned randomness**, draw dark lumps and bumps over your light outline, then erase the extra lines (Figure 3).
4. The light source is above and to the right. Using circular squiggles to shade, shade in the areas away from the light source; be sure to darken most the edges opposite the light source. Blend the value lighter and lighter as you move toward the light (Figure 4).
5. To make the word really pop, darken the background. That's what I call a "wow!" factor (Figure 5)!

5.

30-MINUTE SUNFLOWER

Every time I enter the grocery store I'm tempted to buy one of the bouquets I pass at the front entrance (clever product placement!). More often than not, I do grab some flowers. I enjoy filling my home with color; I have lots of art on the walls and vases full of flowers everywhere. I'm especially drawn to sunflowers. I love how the bright yellow petals radiate from the center. In fact, you can see how the concept of the "sunburst" as an artistic design relates to the sunflower!

LOCATION

I'm drawing this lesson at a grocery store table near buckets of sunflowers.

SUNFLOWER DRAWING TOOLS

- ▶ Pencil
- ▶ Eraser
- ▶ Paper to draw on—or use the practice page 55
- ▶ Quarter
- ▶ Nickel
- ▶ Dime

TODAY'S SUNFLOWER

I dare you not to smile when you see a sunflower! Impossible!

SHAPES IN A SUNFLOWER

DECONSTRUCTED SUNFLOWER

Before You Begin . . .
Read these two pages.
No drawing yet!

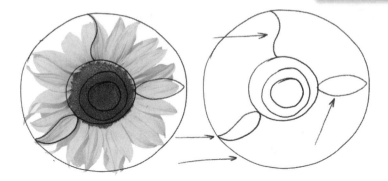

Sunflowers are so much fun to draw! The obvious basic shapes—a big circle defining the outside, a few circles within circles for the center—provide an easy **blueprint** within which you'll let your creativity flourish. I see three additional repeating shapes in the petals of the sunflowers—S-curves, skinny lemons, and teardrops. I don't even try to match the petals in the photo; instead, I somewhat randomly repeat these shapes in my drawing. The more irregular the shapes, the more realistic the sunflower looks and the more fun it will be to shade. The repetitive patterns in the sunflower—the tiny seed circles, the S-curves—are meditative to draw. Repetitive patterns, freedom to be imperfect, interesting areas to shade—sunflowers are hands-down one of my favorite things to draw in 30 minutes.

Be a NONperfectionist!

30-MINUTE SUNFLOWER HACKS

Pocket Change for the Seed Pod

Trace a quarter, nickel, and dime to reproduce the circles within circles comprising the seed pod at the center of the sunflower (Figure 1).

Quarter Dot the Large Circle

To hack the large circle in which you'll place your sunflower, you can find a 3-quarter-wide cup to trace, or use the quarter to draw dots you'll then connect to sketch the outside circle (Figures 2 and 3).

1.

2.

3.

MEASURING SHORTCUTS

- ▶ Sunflowers generally have large centers. The center of this sunflower is slightly wider than the petals are long.
- ▶ The large outside **holding circle** is about three times the diameter of the inner circle.

TIPS AND TECHNIQUES

S-Curves, Lemons, and Teardrops

Practice drawing those S-curves, lemons, and teardrops before you start your 30-minute drawing.

4.

Underlapping Petals

I use "underlapping" (and **shading**) to identify which petal is closer and which is farther away.

1. Select five or six petals about equal distance apart to be the ones in front, and draw those first (Figure 4).

5.

2. Next to each petal draw a buddy petal that repeats its shape but is tucked behind it (This isn't exactly what you'll see on the photo, but I like this technique.) (Figure 5).
3. Now, to complete the petals, fill in all the spaces with many shaped petals. Leave out the parts of the petals tucked behind other petals ("underlapped") on one side or the other (Figure 6).

6.

4. Here and there add the tops of variously shaped petals peeping out the back (Figure 7).

Spin the paper to draw comfortably!

Loop-de-Loop Seeds

I like drawing tiny circles for the seeds; I find the repetition relaxing and fun. If you'd like to hack them in quickly, though, draw loop-de-loops! Big ones for the bigger seeds, smaller ones for the middle tiny seeds, and **overlapping** loops for the dark ring between holding circles.

7.

Don't draw neat loop-de-loops like this one for your seeds (Figure 8):

Scribble them for a sunflower center!

8.

DRAW THAT SUNFLOWER!

1. Draw Your Blueprint
5 minutes!

Draw lightly!

- Draw a quarter-sized circle for the center.
- Draw two smaller circles for the seed variations.
- Draw the larger holding circle for the whole flower.
- Add the five or six front petals (see techniques, page 53) (Figure 1).

1.

2. Shape the Shapes
10 minutes!

- Draw matching petals partly tucked behind each front petal you've drawn.
- Draw the rest of the (partly hidden) petals in S-curves and lemon and teardrop shapes.
- Add a few petal tops for the back row.
- Scribble tiny circles for the seeds farthest from the center and tinier circles for the seeds in the center (Figure 2).
- Draw a mix of overlapping tiny and tinier circles on the middle circle (Figure 3).

2.

3.

4.

3. See the Light
10 minutes!

Notice where the light strikes this image.

5.

- Shade in the darkest darks where the petals **overlap** (Figure 5).
- Shade a middle tone where you see **shadows** on the back petals and where the petals connect to the seed pod (Figure 6).
- Use your finger to smooth between levels of shading (Figure 7).

6.

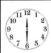
7.

4. Finish Up!
5 minutes!

- Erase the holding circle and any smudges.
- Add details to the petals:

 - Lightly draw a straight line up the middle of each petal to begin detailing the ridges.
 - Lightly draw curved lines on either side of the straight line, mirroring the curve of the outside of the petal.

- Darken and define the shadows (Figure 8).

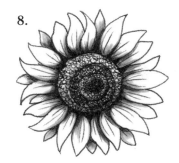
8.

BONUS CHALLENGE: PETALS

I love drawing sunflowers so much! Here's a different flower from my imagination; drawing it is a fun way to practice the overlapping shapes that add **dimension** to any drawing. Here I use a cool compass trick to determine where I put each petal as the rows recede.

1.

1. *New Sunflower Blueprint.* Draw your holding circles as you did for the 30-Minute Sunflower, but before you draw any petals, lightly draw a vertical line intersected by a horizontal line through the center of your circles. **Bisect** those with diagonal lines as shown (Figure 1).

2.

2. *First Petal Layer.* Draw petals straddling each of your compass lines, employing a variety of the shapes you learned in this chapter (Figure 2).

3. *Second Petal Layer and Guide Dots.* Draw partial petals (the top parts) peeking out from between each of the petals in the first layer. Next, draw guide dots between the tips of the first and second layer petals as shown (Figure 3).

3.

4. *Final Petal Layer.* Placing the tips of these petals on or near your guide dots, draw in the partial petals of the third layer. The petals in each layer moving backward are progressively smaller and more numerous (Figure 4).

4.

5. *Shade.* Imagine your **light source** hitting your flower straight on so each layer will be shaded darker than the one in front of it (as the layers get closer to the light). Draw darkest darks where overlapping petals touch and where the front petals attach to the center (Figure 5).

6. *Add Details.* I define the petals' wrinkles and ridges in this drawing a little differently from our 30-Minute Sunflower. This time I use **planned randomness** to vary the lengths and curves of the defining lines in each petal. I sketch in the seed rings at the end (Figure 6).

5.

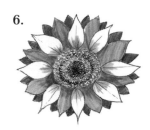
6.

30-MINUTE NOSE

I'm sitting on an airplane heading toward Wichita. I look around me: noses everywhere! I'm inspired! People sometimes think noses are really hard to draw (okay, me too), but they don't have to be. All human noses consist of similar basic shapes. See the world as artists do—find the simple and familiar within the complexities. Draw the basic shapes to create your **blueprint**, then refine the shapes, add shade and style—and know the nose.

Okay, people are giving me very peculiar looks for staring at their noses, so let's get drawing!

LOCATION

I'm drawing this lesson on an airplane on the way to Wichita, Kansas.

NOSE DRAWING TOOLS

- ▶ Pencil
- ▶ Eraser
- ▶ Paper to draw on—or use the practice page 61
- ▶ Paper to trace (a dollar bill works well)
- ▶ A nickel
- ▶ A dime

TODAY'S NOSE

In this lesson we're drawing my nose, but you can draw your own nose (take a selfie!) or anyone else's nose in 30 minutes.

SHAPES IN A NOSE

DECONSTRUCTED NOSE

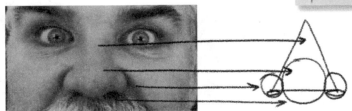

Before You Begin . . .
Read these two pages.
No drawing yet!

Instead of looking at my nose as a nose, look for the common geometric shapes. See the triangle, circle, and oval? Much easier to draw when you think that way. Confession time—I'm obsessed with food. When I deconstruct the nose in this picture I don't actually see simple shapes; I see produce—oranges, peaches, bananas, and watermelon. I guess when it comes to simplifying the world around you, the metaphor doesn't matter. Let your mind turn a complex object into whatever shapes help you see it as a group of recognizable parts. Take another look. Tell me you don't see two grapes and a plum on that triangle!

30-MINUTE NOSE HACKS

Big Triangle Hack

To make the big triangle in your nose **blueprint**, grab something with a corner and trace it. I used a dollar bill (Figure 1).

Use the bill to draw the straight line across the bottom of the triangle too (Figure 2).

Nose Bridge Hack

Draw two dots on the bottom line of your big triangle, about a finger's width from the triangle corner (Figure 3).

Draw light lines from your dots to the tip of your triangle, and *voilà*! (Figure 4).

You don't have to use the dollar bill hack, of course. It's even quicker to sketch a free-form narrow triangle.

1.

2.

3.

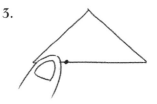

4.

Nose Tip and Sides Hack

Trace a nickel or a quarter to draw the circle for the nose tip. Pop the nickel or quarter between the two dots you made in your nose bridge hack. Trace the dimes, placed on each side of the nickel, for the sides of the nose. Don't worry about being exact (Figures 5 and 6).

5.

6.

Nostril Hack

Use your pinky to trace a nice oval arc to define both the top and the bottom of the nostrils. First erase the extra lines, and then draw the top half of the oval (Figure 7).

Now, flip the paper over to draw the bottom of the nostril (Figures 8 and 9).

A note: when you use the 30-minute instructions on the next pages, add the nostril holes *after* you've refined the nose shape.

7.

8.

> *Draw more, not harder, to make areas darker. Better to go over and over your lines than to draw heavy lines you can't erase.*

9.

Nose Shading Hack

Squint. That's how to quickly figure out where to shade. Look at the nose you plan to draw (in this case, the picture of my nose). The "darkest dark" **shadows** and the "lightest lights" become obvious when you view any image through almost-closed eyelids (Figure 10).

10.

DRAW THAT NOSE!

 1. Draw Your Blueprint

5 minutes!

Draw lightly!

- Create your **blueprint** by drawing the basic triangle and three circles of the nose; hack if you like (Figure 1).
- Don't draw the nostril holes yet.

1.

 3. See the Light

10 minutes!

Notice where the light strikes this image.

- Shade the darkest dark areas you see (Figure 7).
- Add the shapes of the nostril holes, and darken those (Figure 8).
- Shade the whole nose—lighter where it's light, darker where you see more shadows (Figure 9).
- Erase the lightest areas you see (Figure 10).

7.

8.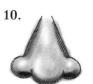

9.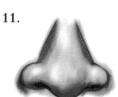

10.

 2. Shape the Shapes

10 minutes!

- Widen or narrow the sides of your triangle to match the nose you're drawing. Draw right on top of your **blueprint** (Figure 2; dotted lines show my blueprint lines).
- Look at your nose-side circles: Do they need squishing to match the photo? Squish away (Figures 3 and 4)!
- Okay, my real nose isn't a triangle. The top is open and leads to my forehead. Erase the triangle top (Figure 5).
- Erase the lines you no longer need (Figure 6).

2.

3.

4.

5.

6.

 4. Finish Up!

5 minutes!

- Blend the **shading** with your pencil or finger.
- Darken the darkest spots; add edges if you like.
- Erase the extra lines (Figure 11).
- Enjoy your drawing!

I love my 30-minute nose! Is it perfect? Of course not. Am I happy? You bet.

11.

YOUR
DRAWING
PAGE

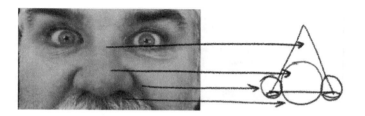

BONUS CHALLENGE: SEE LIKE AN ARTIST

Learn This → from That!
How can you see things as an artist? Find the basic shapes around you. Learn to shade tricky objects like noses by practicing shading simple objects like spheres.

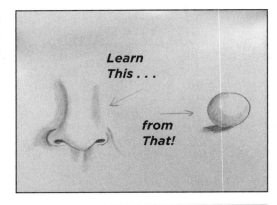

To Get Good at That → Practice These!

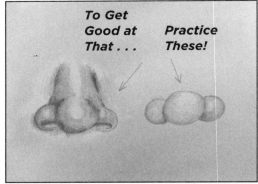

This Makes It Cartoony → This Makes It Realistic
Hard, solid lines → Soft, blended lines

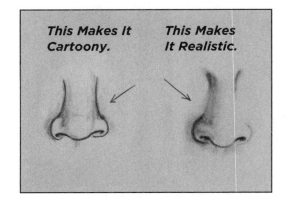

LESSON 10

30-MINUTE SEAHORSE

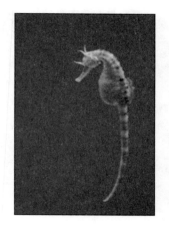

Oh man, I love these little critters! Their patterns of stripes and spots are an awesome example of **natural design**. (More examples: a bird's feathers, the veins on a leaf, the scales on a fish, the grain in bark, the patterns on a turtle's back or a zebra or a giraffe or, or, or . . . nature is endlessly amazing!) Seahorses seem to glow like tiny electric lights. They're no bigger than your thumb yet so colorful and fascinating! Besides penguins, seahorses are my favorite exhibit at Moody Gardens Aquarium.

LOCATION
I'm drawing this at the Moody Gardens Aquarium Pyramid on Galveston Island, south of Houston, Texas.

SEAHORSE DRAWING TOOLS

- ▶ Pencil
- ▶ Eraser
- ▶ Paper to draw on—or use the practice page 67
- ▶ Quarter
- ▶ Dime

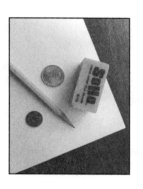

TODAY'S SEAHORSE

So tiny, so magical!

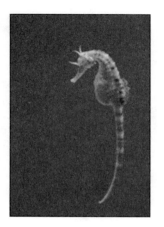

SHAPES IN A SEAHORSE

DECONSTRUCTED SEAHORSE

Before You Begin . . .
Read these two pages.
No drawing yet!

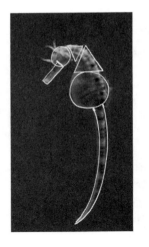

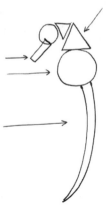

Drawing a seahorse quickly is easier than you might think. Once you draw the circle-shaped belly to ground your drawing, the other shapes become obvious. Each shape you draw helps you place the next shape. The most interesting part of this drawing, for me, is the **shading** because the seahorse is translucent.

30-MINUTE SEAHORSE HACKS

Quarter for the Body

Trace a quarter to draw the circle that forms the seahorse's body (Figure 1).

Draw Progressively for Accurate Placement

Use each shape in this drawing to determine **size** and **placement** of adjacent shapes. Draw in this order:

1. Trace the circle for the body.
2. Add a big triangle above the circle. The triangle is about three-fourths the size of the body circle (Figure 2).
3. Nestle a second triangle, about half the size of the first, next to the first triangle as shown (Figure 3).
4. Add the smaller circle cozied up against the side of the smaller triangle as shown, angled slightly down. See how the top of the small circle is a little higher on the page than the top of the small triangle? Trace a dime for the circle if you like (Figure 4).
5. Use the size and position of the smaller circle to direct your drawing of the rectangle for the nose. It's about as long as the small circle is wide (Figure 5).

1.

2.

3.

4.

5.

Sweep the Tail

Try turning your paper sideways to freely draw the curving lines of the tail. (To get the placement right, before drawing the curved lines, dot the spot where the tail will end.) (Figure 6).

6.

MEASURING SHORTCUTS

- ▶ The seahorse tail is about three seahorse bodies (three-quarters) long.
- ▶ The head is about a third the size of the body.
- ▶ The bottom curve of the tail is almost parallel with the edge of the body.
- ▶ The back line of the tail begins at the back of the bottom of the body (it does not descend from the middle of the body).

TIPS AND TECHNIQUES

Negative Space

This seahorse photo illustrates a great example of **negative space**, which is the space around an object that sometimes is easier to draw and identify than the object itself. See the triangle shape between the head and the body in the photograph? Check against your own drawing. Does the missing triangle have the same proportions (Figure 7)?

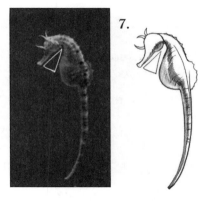

7.

> *Notice the repeating groups of spots and stripes on the seahorse's skin? Look around you—you'll find repeating clusters forming recognizable designs everywhere in nature!*

Shading a Translucent Object: A Fun Challenge!

Light actually comes *through* the seahorse's translucent body, so I create the effect by shading both the *side* of the body away from the light and the *back* of the body through the light. The translucence causes the darkest part of the seahorse to be down the center rather than on either side, so I shade the darkest down the center, blending lighter as I move toward the edges. If needed, lightly erase the translucent areas, keeping a milky light gray value (Figure 8).

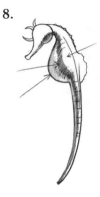

8.

DRAW THAT SEAHORSE!

 1. Draw Your Blueprint
10 minutes!

Draw lightly!

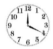
1.

- ▶ Draw a quarter-sized circle for the body.
- ▶ Draw two triangles for the neck.
- ▶ Draw a dime-sized circle for the head.
- ▶ Draw a rectangle for the snout.
- ▶ Draw two three-quarter-length curving lines for the tail (Figure 1).

 2. Shape the Shapes
10 minutes!

2.
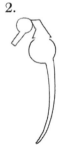

- ▶ Erase all extra lines *except* the line between the head and neck (Figure 2).
- ▶ Smooth out and curve the back, neck, and top of the seahorse snout, and if needed, add definition to the belly (Figure 3).
- ▶ Erase original **blueprint** lines; add more detail:

3.

 - ▶ Draw three visible horns.
 - ▶ Bulb out the end of the snout.
 - ▶ Draw the back fin.
 - ▶ Define the spine and some ridges with **contour lines** (Figure 4).

4.

 3. See the Light
5 minutes!

Notice where the light strikes this image.

5.

- ▶ Shade under the snout and jaw.
- ▶ Shade the side of the stomach and tail opposite the light.
- ▶ Shade in the darkest spots in the middle of the body, further define the tail by drawing a shadow next to it, and add some of the ridges (Figure 5).
- ▶ If needed, lightly erase the translucent areas near the edges so they're a milky tone (Figure 6).

6.

 4. Finish Up!
5 minutes!

7.
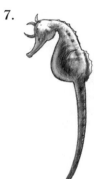

- ▶ Add patterns of dots and stripes on the snout, head, spine, and tail.
- ▶ Add more curved ridges down the entire spine (starting at the head), grouped in irregular patterns as they move down the tail (Figure 7).

YOUR
DRAWING
PAGE

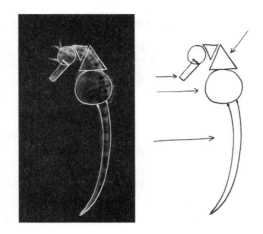

BONUS CHALLENGE: LEAFY SEA DRAGON

I drew a seahorse, and now I'm hooked! Let's take it even further and draw a sea DRAGON! Leafy sea dragons look like seahorses hiding in seaweed, but look closer: The seaweed *is* the sea dragon. The leaf shapes grow out of their own bodies so they blend in perfectly with the kelp in which they live. Mind-boggling and magnificent. There is no way to mess this one up—it's supposed to look chaotic and visually confusing. So relax and have at it!

1. Draw a tilted oval, about an inch tall. Sketch in lines for the neck, then add another smaller tilted oval for the head (Figure 1).
2. Draw the wiggly tail and the trumpet snout (Figure 2). Erase interior lines.
3. Map in the basic shapes of the leafy appendages in two stages: First, randomly draw slightly curved lines for the "stems" (Figure 3).
4. Next, draw ovals of various sizes flowing back from the stems. Don't try to match the photo or my drawing; just have fun (Figure 4).
5. Refine the shapes; erase interior lines (Figure 5).
6. Shade away from the light source, and add kelp-like spots on this turbo-cool critter (Figure 6).

1.

2.

3.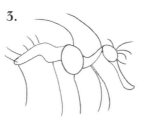

4.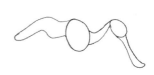

5.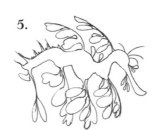

6.

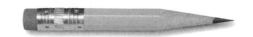

30-MINUTE PENCIL

I love those silly, stubby pencils they give you at miniature golf courses to keep score. So how could I resist drawing a pencil when I'm not only at a mini-golf course but the course is in PENCILcola, Florida?! Okay, it's actually "Pensacola," but still. I find inspiration everywhere, and good humor helps too. If you're playing putt-putt with a crowd, use your waiting time to sketch right on the scorecard. Why not? If you really care about your score in mini-golf, you may need a relaxing drawing break to put that putt-putt back into perspective.

LOCATION

I'm drawing my pencil at a mini-golf course in Pensacola, Florida.

PENCIL DRAWING TOOLS

▶ Pencil
▶ Eraser
▶ Paper to draw on—or use the practice page 73

TODAY'S PENCIL

A well-used tool.

SHAPES IN A PENCIL

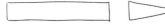

DECONSTRUCTED PENCIL

Before You Begin . . .
Read these two pages.
No drawing yet!

Little pencil, big image!

The pencil **blueprint** is simply a triangle and a rectangle, with the rectangle subdivided into smaller rectangles. An easy start to your 30-minute drawing! It's the **shading** and **highlights** that make a pencil look pencil-like.

30-MINUTE PENCIL HACKS

Highlight Hack

The bright spots on the pencil really give it **dimension**. Leaving the paper white for the highlights makes the whites pop, but it's easy to accidentally shade right over them. Draw light outlines for the places you want to keep untouched before you start shading (Figure 1).

1.

MEASURING SHORTCUTS

▶ The eraser and metal casing together are about the same length as the wood tip and lead point together.

TIPS AND TECHNIQUES

Fifty Shades of Grayish

This book is black and white, but notice how your eye intuits the color of the red eraser, the silver metal band, the yellow-orange body, and the wood tip? That's partly because we impose our experience of "pencil" onto the image, but it's also due to the differences in value of each shade of gray.

In a black-and-white sketch we can vary the shades of gray to indicate color as well as shading based on where light hits the object. For this stubby pencil, only after I've added "colors" do I shade based on where highlights and **shadows** fall (Figures 2 and 3).

You can create the impression of different colors by varying the direction and intensity of your shading. See how my lines in the eraser are vertical, the lines in the body are horizontal, and the lines on the tip are angled? Even though I smooth out the shading in the end, the hint of directional changes tricks the eye into seeing different colors (Figure 4).

2.

3.

4.

DRAW THAT PENCIL!

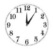 ### 1. Draw Your Blueprint
5 minutes!

Draw lightly!

- ▶ Draw a rectangle.
- ▶ Draw a triangle.
- ▶ Add a line for the pencil lead.
- ▶ Add lines for the eraser and metal end (Figure 1).

1.

 ### 2. Shape the Shapes
10 minutes!

- ▶ Sketch horizontal lines for crimps in metal as shown. Squiggle the line where the pencil has been sharpened (Figure 2).
- ▶ Add **holding lines** for highlights (see page 70) (Figure 2).
- ▶ Shade your pencil to suggest colors (see page 71) (Figure 3).
- ▶ Smooth it with your finger (Figure 3).
- ▶ Color in the lead (Figure 3).

2.

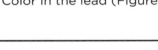

3.

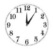 ### 3. See the Light
10 minutes!

 Notice where the light strikes this image.

4.

- ▶ Add the darkest darks under the pencil.
- ▶ Add midtones to the top and bottom of the pencil (Figure 4).

 ### 4. Sharpen Your Pencil
5 minutes!

- ▶ Erase unnecessary lines.
- ▶ Add detail to the metal.
- ▶ Darken the outline of the pencil (Figure 5).
- ▶ Draw! Draw! Draw!

5.

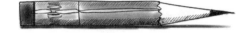

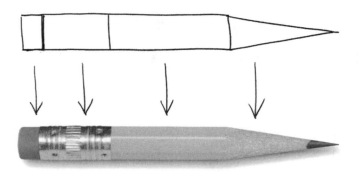

BONUS CHALLENGE: BRING YOUR PENCIL TO LIFE

1.

I'm a huge fan of Chris Van Allsburg, author and illustrator of such amazing books as *The Polar Express*, *Jumanji*, and my favorite, *The Z Was Zapped*. I'm in awe of the way he renders both everyday and fantastical objects so realistically that they jump off the pages of his books—yet he stylizes just enough so you always know you're looking at drawings. Magical! I thought of him as I created this lesson for going beyond the first 30 minutes to take an ordinary pencil and attempt to animate it. The stubby pencil is a simple object, easy to bring to life with a little **perspective**, angling, and shadows. (I'm drawing this pencil from my imagination, referring back to the photograph opening this chapter when I need a reminder of pencil details.)

2.

1. Draw an open sideways "V" to create guidelines for the pencil and the ground shadow below it (Figure 1).
2. The top line of the "V" **bisects** the pencil. Keeping that line in the center, sketch in each chunk of the pencil from the bottom up: first draw the lead, then the wood, then the pencil body (Figures 2 and 3).

3.

3. The pencil gets narrower as it goes back in space! So refine your drawing by **tapering** the sides. Add curving lines indicating the metal, the eraser, and the lead (Figure 4).

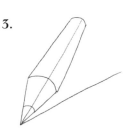

4.

4. Erase the center holding line and other extra lines. Add a strong ground shadow along the bottom of the "V." Find your **light source**, and darken the pencil areas farthest from the light. Smooth shading with your finger or the "stumpy" technique (see page 6) (Figure 5).

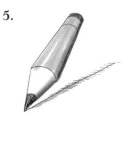

5.

5. Finally, add missing details (the crimping in the metal, the lead in the tip, and the squiggle where the pencil has been sharpened). Erase highlights, and watch your pencil lift off the page! (Figure 6).

6.

30-MINUTE BELL PEPPER

Yum! I love raw veggies, and this bell pepper looks delicious. The smooth skin catches the light and gleams, even in a black-and-white image. The bell pepper provides a terrific opportunity to learn how to use natural **highlights** to create the illusion of round-ness and shine. My artist friend Anat Ronen helped me get this pepper lesson started—thanks, Anat! Anat's murals and illustrations will take your breath away—see some at www.anatronen.com.

LOCATION

I'm drawing this pepper in my kitchen, eating a salad with Asian dressing.

BELL PEPPER DRAWING TOOLS

- ▶ Pencil
- ▶ Eraser
- ▶ Paper to draw on—or use the practice page 79
- ▶ Quarters
- ▶ Nickel

TODAY'S BELL PEPPER

Is the pepper in this photo red or green? What do you think?
Hint: It's red.

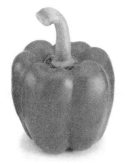

SHAPES IN A BELL PEPPER

DECONSTRUCTED BELL PEPPER

Before You Begin . . .
Read these two pages.
No drawing yet!

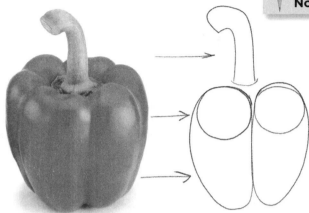

It's tempting to draw this pepper from the top down, starting with all those bumps and humps up top. I recommend ignoring them and starting instead with two circles for the upper parts of the visible humps in front. Next, sketch in the two almost-ovals that form the rest of the big humps in front. Later we'll draw the remainder of the pepper bumps relative to the first two; that way there's a point of reference to help draw them in proportion. The highlights are key elements in this photo. Don't draw them—leave the paper white if possible. It's fun to carefully shade around the highlights and watch the pepper on the paper come to life!

30-MINUTE BELL PEPPER HACKS

Trace Coins for the Pepper Humps

Start your drawing by tracing a quarter for the upper part of the big-gest hump. Move the quarter off to the side, and place and trace a nickel for the second, smaller hump adjacent to the first hump (the larger circle) (Figure 1).

Use Coins to Place Ovals

As long as you have those coins out, use them to hack the placement of the almost-oval shapes that overlap and extend down from the circles you just drew.

1. Place a quarter below the larger circle and the nickel below the smaller circle.
2. Draw light guidelines adjacent to the sides of the coins. Draw additional guidelines below the coins as shown, leaving some space between the bottom of the coins and the guidelines (Figure 2).
3. Move the coins off to the side (Figure 3).

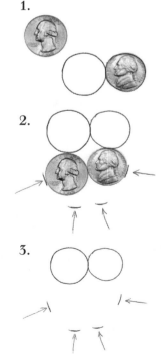

1.

2.

3.

4. Lightly sketch in an almost-oval shape overlapping the larger circle, using the guidelines (Figure 4).
5. Sketch in the second almost-oval (Figure 5).

MEASURING SHORTCUTS

▶ This pepper is about as tall as it is wide.
▶ Use the "pencil-measure" hack on page 6 if you don't have a quarter handy.

TIPS AND TECHNIQUES

Use Relative Placement to Draw the Pepper Top Bumps

Replicating an object comes down to conscious "seeing," as so many drawing teachers say. But what does that mean? Often it's simply a matter of focusing on (1) where parts of the object intersect other parts, and (2) how big the new part of the object is relative to the other parts already drawn.

This illustration shows the order in which I drew the top curves, looking at each previous curve to size and place the next (Figure 6).

Highlight Mapping

Highlights can be erased at the end of a drawing or left white during the drawing process. I try to leave the paper white, but that's not always possible. The highlights are key and numerous in this pepper, so I suggest lightly circling them as a reminder not to shade those areas.

Here's my highlight map for the red pepper (Figure 7).

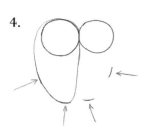

4.

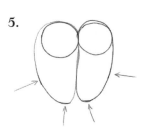

5.

6.

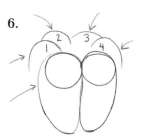

7.

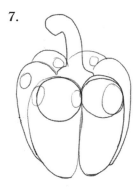

DRAW THAT BELL PEPPER!

1. Draw Your Blueprint

5 minutes!

Draw lightly!

- ▶ Draw two circles for the top pepper humps (see hack).
- ▶ Draw two ovals overlapping the circles for the main pepper body (see hack).
- ▶ Add the stem shape (Figure 1).

1.

2. Shape the Shapes

10 minutes!

- ▶ Draw the remaining four top humps, placed relative to stem and front bumps (Figure 2).
- ▶ Extend outside edges, shape as needed (Figure 3).
- ▶ Lightly circle the highlights (Figure 4).

2.

3.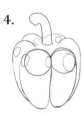

4.

3. See the Light

10 minutes!

Notice where the light strikes this image.

5.

- ▶ Draw the darkest nooks, crannies, and overlapping areas (Figure 5).
- ▶ Add midtones and additional dark areas as you see them, leaving highlights white (Figure 6).

6.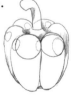

4. Finish Up!

5 minutes!

- ▶ Darken the darkest spots to add definition.
- ▶ Add detail to the stem.
- ▶ Erase any smudges in the highlights.
- ▶ If you like, draw a **cast shadow** to anchor the pepper to the surface (Figure 7).

7.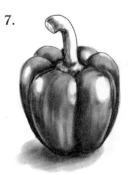

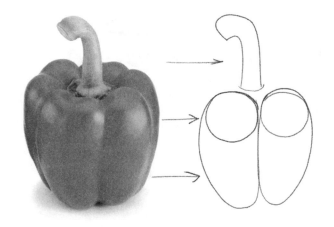

BONUS CHALLENGE: MOVE THE LIGHT AROUND

Because the bell pepper picks up shine so well and has those wonderfully distinctive bends and curves, it's a great object on which to practice highlights and **shadows** relative to those highlights. Let's start with the pepper we just drew. Sketch it again, twice, as if two peppers are sitting next to each other on a table. Don't add the shadows yet. See how quickly you can draw it now that you've done it once in 30 minutes . . . and . . . go!

Now:

1. Draw a **light source**.
2. Draw a highlight map based on where the light will hit each pepper. (Draw light rays coming from the source to guide you if you like.) The light will hit each of your two peppers in different spots.
3. Shade, shade, shade! Start with the darkest darks, and leave the highlights white.
4. Blend harsh lines, and add **cast shadows**.

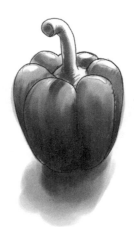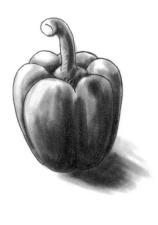

LESSON 13

30-MINUTE CELL PHONE

I should be writing this book, but instead I'm distracted by what I call the "procrastination machine." You know what I mean: that marvelous yet addictive and isolating invention, the cell phone. Each of us struggles every day to find the right balance . . . Hey! The perfect solution! I'll *draw* it rather than let it control me!

Ordinary objects we often take for granted, from doorknobs to car keys to cell phones, can actually be very interesting to draw. Design is integral to many devices that once were merely functional. In some instances the artistry underlying the object is breathtaking. And when we're drawing technology instead of surfing it, we're engaged in the world around us.

LOCATION
I'm drawing this in my kitchen.

CELL PHONE DRAWING TOOLS

▶ Pencil
▶ Eraser
▶ Paper to draw on—or use the practice page 85
▶ Cell phone!

TODAY'S CELL PHONE

By the time you read this I'm sure there will be a new model of this phone. Oh well!

SHAPES IN A CELL PHONE

DECONSTRUCTED CELL PHONE

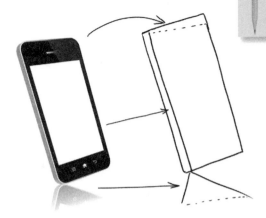

Before You Begin . . .
Read these two pages.
No drawing yet!

When I see beautiful, functional objects, I like thinking about the original design. Someone, somewhere, sketched it out with pencil and paper as the first step on its journey to ubiquity. But I digress. Obviously, a cell phone is pretty much a rectangle, but rectangles don't have **dimension**. To bring this cell phone to life, I draw a rectangle on an angle, then remove a triangle shape from the top. The **shadow** below the cell phone in the image is a basic triangle; the edge of the cell phone is a very skinny rectangle.

30-MINUTE CELL PHONE HACKS

Cell Phone Distorted Rectangle Hack

1. Use your own cell phone to get the sides of your basic rectangle on the page. Place your cell phone on the paper, and slide it so it angles upward. Use the right side of your phone as a guide to draw the far side of the rectangle.
2. Slide your phone toward you about an inch, keeping the same angle. Draw the left (closer) side of the phone (Figure 1).
3. Draw the top and bottom lines of your angled rectangle (Figure 2).

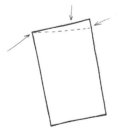

TIPS AND TECHNIQUES

Distortion

Without **distortion** (**perspective**) to trick us into seeing three dimensions, drawings can look flat. So I remove a triangle shape from the top of my angled rectangle. The bottom of the triangle (the dotted line in Figure 2) matches the angle of the top of the cell phone in the photo. This distorts the rectangle, making the back line shorter than the one closer to us.

Tiny Corners, Big Impact

The skinny rectangle shape on the side of the phone can make your drawing look very realistic if you remember to round the corners.

Reflections and Icons

The reflection of the phone and the icons on the phone's face are important details of the cell phone pictured. How do you add a white area without a white pencil? Let the white of the paper do the work for you, and draw **holding lines** to remember what goes where.

▶ For the icons at the cell phone's top and bottom, lightly draw **holding circles** to position your icons. Then sketch the outlines of the icons—you'll shade around them. No need for perfection (Figure 3).
▶ For the bright white reflection along the edge of the phone, draw a holding line parallel with the near side of the phone, and only shade below it (Figure 4).

3.
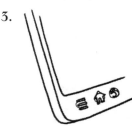

MEASURING SHORTCUTS

▶ The back line of the phone is shorter than the front.
▶ The height of the phone is about two and half times its width.
▶ The lines of the rectangular cell phone screen are each parallel to the outside lines of the phone. (For example, if the bottom of the phone angles up, so does the bottom of the screen.)

4.

DRAW THAT CELL PHONE!

1. Draw Your Blueprint

5 minutes!

Draw lightly!

1.

- ▶ Draw a large rectangle on an angle (see hack, page 82).
- ▶ Draw a line inside the top of the rectangle to form a triangle.
- ▶ Draw a skinny rectangle on the left (near) side of the large rectangle.
- ▶ Lightly draw a triangle below the left corner of the primary rectangle (Figure 1).

2. Shape the Shapes

10 minutes!

2.

- ▶ Erase the rectangle top.
- ▶ Lightly draw the cell phone's inside screen and holding circles for the icons (see page 83).
- ▶ Sketch the icons.
- ▶ Lightly draw a holding line around the edge **highlight**.
- ▶ Round the cell phone corners. Erase the original sharp edges.
- ▶ On the triangle reflection, round the corners, and sketch in the side and the screen (Figure 2).

3. See the Light

10 minutes!

Notice where the light strikes this image.

3.

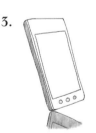

- ▶ Lightly shade the skinny rectangle on the side, leaving the highlight white (see page 83) (Figure 3).
- ▶ Shade the whole shadow triangle below the phone this same tone (Figure 3).
- ▶ Shade the darkest areas of the phone front, leaving the icons white (Figure 4).

4.

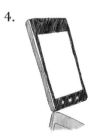

4. Finish Up!

5 minutes!

- ▶ Erase any of the white areas that have gotten smudged or were overlooked.
- ▶ Add tone to the screen by sketching lightly, then smoothing with your finger.
- ▶ Darken dark areas.
- ▶ Erase any remaining dotted lines (Figure 5).
- ▶ *Whoops, gotta go—just got a text!*

5.

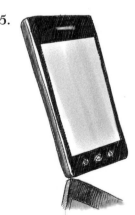

YOUR DRAWING PAGE

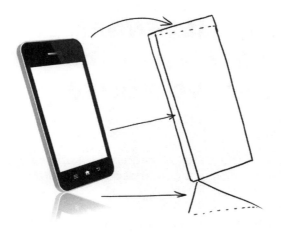

BONUS CHALLENGE: SKETCH A PLAYING CARD HOUSE

Look around—you'll soon see the distorted rectangle shape everywhere! Here's a fun sketch for practicing your rectangular drawing chops.

1. Draw a distorted rectangle on an angle using the technique you learned in this chapter (see page 82) (Figure 1).
2. Draw two parallel lines angling down from each top corner.
3. Draw the bottom of the back rectangle higher on the paper than the bottom of the front rectangle, as shown (Figure 2).
4. Shade the back rectangle; add shadow under both cards (Figure 3).
5. Make the shadow darkest where the light hits least and also where the back and front cards intersect with the table (Figure 3).
6. Roughly sketch in the card number and suit. If you're feeling ambitious, make it a face card! (Figure 4).

1.

2.

3.

4.

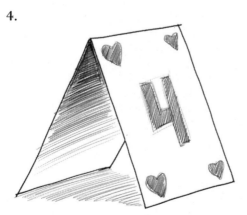

30-MINUTE SOUP CAN

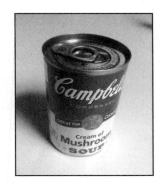

I've always been fascinated by Andy Warhol's paintings as well as the stories of him and his eccentric circle of friends. Warhol popped into my head last Thanksgiving as I was making our good old green-bean casserole with Campbell's Cream of Mushroom soup. Have you seen Warhol's iconic paintings of Campbell's soup cans? Warhol created quite a stir when he painted thirty-two hyper-realistic paintings of soup cans, one for each variety that Campbell's Soup Company made back in 1962. And get this—he used hacks! He traced projections of store-bought soup cans onto his canvas before he began painting them. His paintings are wonderful examples of the power of visual imagery, hanging to-day in New York's Museum of Modern Art and recognized around the world. Hey, if a soup can is good enough for the MOMA, it's good enough for us.

LOCATION

I'm drawing this soup can at a restaurant in Fairhope, Alabama, from a picture I took last Thanksgiving.

SOUP CAN DRAWING TOOLS

- ▶ Pencil
- ▶ Eraser
- ▶ Paper to draw on—or use the practice page 91
- ▶ Soup can

TODAY'S SOUP CAN

Mmm mmm good!

SHAPES IN A SOUP CAN

DECONSTRUCTED SOUP CAN

Before You Begin . . .
Read these two pages.
No drawing yet!

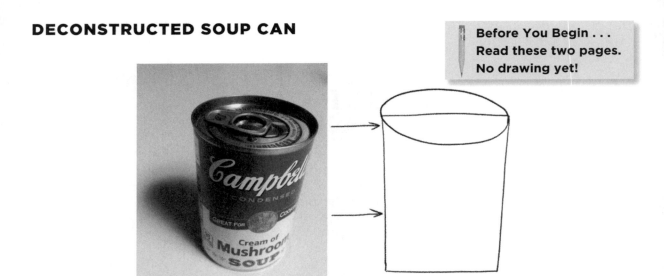

I bet you can figure out the soup can's basic shapes without much instruction. I see a rectangle with an oval the same width **bisecting** the rectangle's top. The **blueprint** for your soup can should take no time at all—which will leave you more time for refining your drawing and playing with **perspective** and contour when you draw the label.

30-MINUTE SOUP CAN HACKS

Trace a Soup Can to Shape the Shapes

After you've drawn the **blueprint**, you'll refine it to better match the photo. Use a real soup can to hack the drawn can's bottom and sides—there's something very Warholian about that!

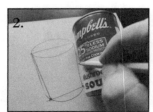

▶ Trace a real soup can to draw the semicircle-shaped bottom as shown (Figure 1).

▶ After you draw your rectangle basic shape, redraw the sides so they **taper** in. You can use the side of anything straight to keep your lines straight—a book, a piece of paper . . . or even the side of a can of soup (Figure 2)!

MEASURING SHORTCUTS

▶ Using the "pencil-measure" hack (see page 6), you'll see the length of the oval is about the same as the height of the soup can (Figures 3 and 4).

▶ The tapering guide dots are about the width of a pencil in from your original rectangle's bottom corners (Figure 5).

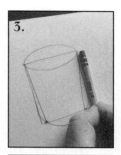
3.

TIPS AND TECHNIQUES

Perspective: A Mix of Size and Placement

The most difficult part of this sketch is drawing the letters realistically on the label as it curves around the can.

Take a look at the photo of the soup can. Do you see how the letters that are nearest to us appear both *larger* and *lower* than the letters that are farther away?

Objects look smaller as they recede in space (imagine a road or railroad tracks). Drawing them as such is an important component of perspective. The letters on the soup can, however, change in **placement** as well as in **size** because the can is a cylinder. Nearer letters look *lower* than farther letters as well as *larger* than farther letters.

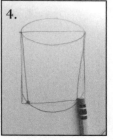
4.

> *Using both **size** and **placement** to create perspective is more effective in quickly making your drawing look realistic than trying to copy the letters exactly.*

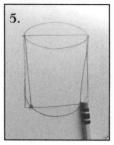
5.

Use Contour Lines to Place the Lettering

Draw curved guidelines to place the letters.

▶ Starting from the bottom, lightly draw semicircles (**contour lines**) on your soup can. The curves on the bottom will more closely match the curve of the bottom of the can, and the ones on the top will more closely match the bottom of the oval-shaped can top (see page 17 to practice contour lines) (Figure 6).

▶ Sketch letters (or squiggles representing letters) on those lines, making the letters *smaller* as well as *higher* as they recede to the sides of the can (Figure 7).

6.

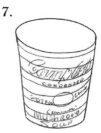
7.

DRAW THAT SOUP CAN!

 ### 1. Draw Your Blueprint
5 minutes!

Draw lightly!

▶ Draw a rectangle.
▶ Draw an oval **bisecting** the top of the rectangle (the top of the soup can) (Figure 1).

1.

2. Shape the Shapes, Part One
5 minutes!

▶ Draw a semicircle for the bottom of the soup can.
▶ Place guiding dots on the semicircle (see page 89) (Figure 2).
▶ Draw tapered lines between the dots and the top edges of the rectangle for the sides (Figure 3).
▶ Erase the original rectangle (Figure 4).

2.

3.

4.

 ### 3. Shape the Shapes, Part Two
10 minutes!

▶ Lightly draw **contour lines** to guide your lettering, making them curvier at the bottom and flatter as they progress up the soup can (see page 89).
▶ Sketch in lettering (Figure 5).
▶ Add the back semicircle for the indented can top (Figure 6).
▶ Sketch the pull tab—a squished oval shape (Figure 7).
▶ Erase contour guidelines (Figure 7).

5.

6.

7.

4. Finish Up!
10 minutes!

8.

Notice where the light strikes this image.

▶ Shade the left side of the can (Figure 8).
▶ Shade the darkest nooks on the lid and lip (Figure 9).
▶ Draw a **cast shadow** behind and to the can's left (Figure 10).
▶ Polish your drawing by blending in the **shading** with your finger (Figure 10).

9.

10.

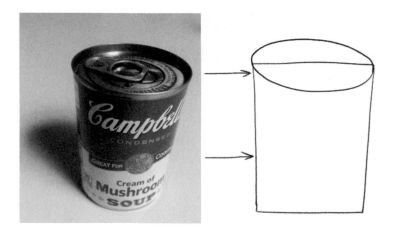

BONUS CHALLENGE: CARTOON CAN

As noted, drawing a soup can reminds me of Andy Warhol's hyper-realistic paintings—so I decided to get playful and take the *opposite* approach in this bonus lesson. Forget realism: let's draw a cartoon! We'll throw accuracy out the window—along with **relative placement** and basic shapes—and just have some fun.

1.

1. Draw two dots about the length of your pinky apart; these dots will be your visual anchors. Using the dots as your guides, draw a squished oval shape. Now, for the soup can sides, draw lines, about the length of your index finger, down from each **anchor dot**, angling the lines in more than you would if you were going for an exact copy. Exaggeration is key in cartoon and caricature (Figure 1).
2. Draw the bottom of the can using a semicircle shape, much curvier than the top of the can (Figure 2).
3. Sketch a circle touching the top left of the can, as shown. Draw squiggly lines around the top oval of the can to suggest a can opener has opened the lid (Figure 3).
4. Add some **contour lines** (semicircles) to help you draw the lettering, then add letters between your lines (Figure 4).
5. Erase all those guide dots and lines (including the contour lines you just drew, unless you want to leave a few to show the edge of your soup can's label). Consider your **light source**. Shade the parts of the can that are farthest away. Exaggerate the darkest darks, and blend the **shadows**.
6. Have fun adding splashes and spills (Figure 5)!

2.

3.

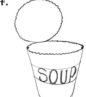
4.

5.

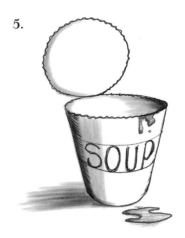

30-MINUTE FINGER

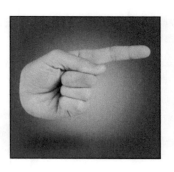

Very excited to give you some "pointers" on a 30-minute finger! I just had to include this lesson. First of all, as an instructor, I'm always pointing to drawings; in fact, my life is filled with both giving and receiving directions. This lesson is also . . . handy! For my kids' pool parties I've drawn this pointing finger on paper plates, cut them out, and taped them up to point to bathrooms, towels, and even parking. You will think of a thousand fun and practical uses for this quick pointing finger drawing.

LOCATION
I'm drawing this in my kitchen.

FINGER DRAWING TOOLS

- ▶ Pencil
- ▶ Eraser
- ▶ Paper to draw on—or use the practice page 97
- ▶ Keurig K-Cup coffee pod
- ▶ Tea bag (in package)
- ▶ Spoon

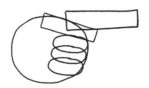

TODAY'S FINGER

You—yes, I mean **YOU**—will do a great job on this drawing!

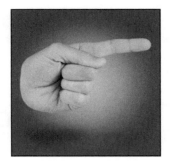

SHAPES IN A FINGER

DECONSTRUCTED FINGER

Before You Begin . . .
Read these two pages.
No drawing yet!

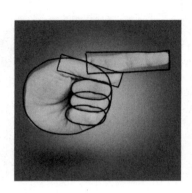

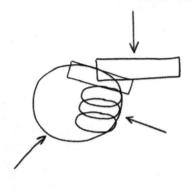

The prospect of drawing hands often daunts my students. Once we break the drawing into recognizable shapes, the nerves vanish. I see the palm-with-folded-fingers shape as a big circle and the fingers as rectangles and ovals placed on and adjacent to that first circle. If your finished drawing doesn't match this photo exactly, relax! There are 7 billion people on planet Earth, so there are approximately 14 billion hands, with 140 billion fingers and thumbs. However your human pointing finger turns out, chances are there is a pointing finger on this planet that looks just like the one you have drawn.

30-MINUTE FINGER HACKS

K-Cup for the Palm
Trace the top (wider end) of a K-Cup coffee pod for your big circle.

Tea Bag Package for Measuring and Tracing
▶ Trace the edge of a tea bag package when you need a straight line.
▶ Use the short side (top) of the tea bag package to measure:

 ▶ The pointing finger, which is as long as the package
 ▶ The thumb rectangle, which is two-thirds as long
 ▶ The finger tucked under the thumb, which is half as long

Spoon
Use the curved handle of a small spoon if you need a guide to shape the ovals. Trace half the oval, flip your paper, and trace the other half (Figure 1).

MEASURING SHORTCUTS

If you're drawing this hand without hacks, draw each part relative to the length of other parts.

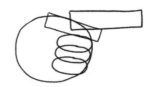

- ▶ The width of the palm circle is the same as the length of the top finger from its first crease to its point.
- ▶ The protruding part of the pointing finger, from thumb tip to fingertip, is just a bit shorter than the thumb is long.
- ▶ The folded fingers and thumb together are about one thumb length tall.
- ▶ The thickest part of the palm next to the folded fingers is about three-fourths a thumb length wide.

TIPS AND TECHNIQUES

Common Mistake

I've talked about the shapes of hands, fingers, and thumbs with artist friends from DreamWorks, Pixar, and Disney. We all agree: the most common mistake beginning artists make when drawing fingers and thumbs is not drawing the tops curving up (Figure 2).

2.
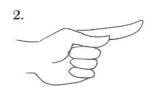

Relative Size for the Fingers

Draw the folding finger adjacent to the thumb first. Each of the remaining fingers moving away from the thumb is progressively smaller.

DRAW THAT FINGER!

1. Draw Your Blueprint
5 minutes!

Draw lightly!

- ▶ Draw a K-Cup-sized circle for the palm and folded fingers.
- ▶ Draw a rectangle for the pointing finger, about as long as the large circle is wide.
- ▶ Draw a rectangle for the thumb, as shown.
- ▶ Draw three ovals for the folded fingers (Figure 1).

1.

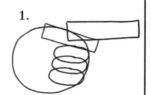

2. Shape the Shapes
10 minutes!

2.

- ▶ Draw the creases in the pointing finger (Figure 2).
- ▶ Refine the hand shape (notice the back of the thumb) and pointing finger (Figure 3).
- ▶ Refine the shapes of the thumb and folded fingers (notice how the thumb top curves up) (Figure 4).
- ▶ Erase extra **blueprint** lines (Figure 5).
- ▶ Define the bottom of the hand, and erase the original line.
- ▶ Add **contour lines** as shown (Figure 6).

3.

4.

5.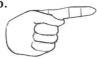

6.

3. See the Light
10 minutes!

Notice where the light strikes this image.

7.

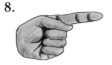

8.

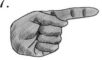

- ▶ Lightly shade the entire drawing.
- ▶ Darken the areas away from the light—define the shadows even more than on the photo (Figure 7).
- ▶ Darken those darkest wrinkles and ridges.
- ▶ Use your finger or stumpy (see page 6) to lightly blend shading (Figure 8).

4. Finish Up!
5 minutes!

- ▶ Erase highlights.
- ▶ Draw the thumbnail, curving to match the contour of the thumb.
- ▶ Draw extra wrinkle lines; erase smudges and darken edges (Figure 9).

Having fun? That's the whole **point!**

9.

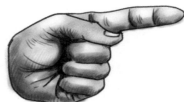

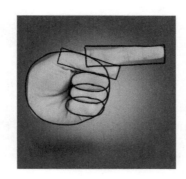 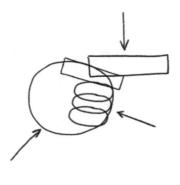

BONUS CHALLENGE: THUMBS UP!

I'm sure you'll agree the planet's most overused—and my personal favorite—emoji in text messages is the "thumbs up." I love this little sucker! It's really fun to draw. As it's a cartoon, we can play with shapes and sizes as much as we like as long as we make sure the image remains recognizable.

1. Draw a quick circle for the palm and folded finger placement (Figure 1).
2. No rectangles in this sketch, as all the fingers are folded and cartoony; instead, draw four stacked ovals for the folded fingers (Figure 2).
3. Add a big thumb. Notice the curved shape of the back of the thumb and the protrusion of the thumb pad (Figure 3).
4. Add the wrist as shown. Erase extra lines (Figure 4).
5. Shade the areas away from the light source (Figure 5). Thumbs up!

1.

2.

3.

4.

5.

30-MINUTE WINE BOTTLE

During dinners out with friends I often find myself absently sketching the wine bottle on the table. I love the simple shapes and **shadows**, each glassy reflection a different yet familiar challenge. The inspiration for this lesson came from a wine bottle I drew in my journal one warm summer afternoon while picnicking in Santa Barbara, California's wine country. (One of my favorite movies, *Sideways*, is set there—if you haven't seen it, rent it now!)

LOCATION

I'm drawing this bottle in an Italian restaurant.

WINE BOTTLE DRAWING TOOLS

- ▶ Pencil
- ▶ Eraser
- ▶ Paper to draw on—or use the practice page 103
- ▶ Credit card
- ▶ Sugar packet
- ▶ Quarter
- ▶ Napkin

TODAY'S WINE BOTTLE

Hiccup!

SHAPES IN A WINE BOTTLE

DECONSTRUCTED WINE BOTTLE

Before You Begin . . .
Read these two pages.
No drawing yet!

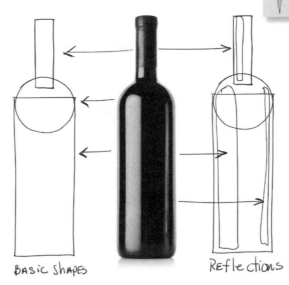

BASIC SHAPES Reflections

The primary shapes you will use to create the **blueprint** for this wine bottle are clear at a glance: two rectangles and a circle. But we can take the basic shapes technique even further. Many people are stumped when it comes to drawing light and shadow, but reflections like those in this beautiful silhouette are, simply, shapes dancing on the glass. I've broken down this deconstruction into two diagrams—the basic shapes of the object itself and the basic shapes of the reflections and shadows.

30-MINUTE WINE BOTTLE HACKS

Credit Card and a Quarter Hack

1.

To quickly **blueprint** the body of the bottle, trace a quarter close to the middle of your drawing page (Figure 1).

Place the credit card halfway over the circle you've just drawn. Draw a rectangle with three sides by tracing the top, bottom, and long side of the card, BUT only make the top and bottom as wide as the circle (Figure 2).

2.

Draw the final side of the rectangle (Figure 3).

Sugar Pack Hack

3.

Instead of a credit card, you can use the sugar and fake sugar packets on the restaurant table for tracing.

MEASURING SHORTCUTS

▶ The bottleneck is almost exactly half the width of the bottle body.
▶ The bottle body is about two and a half times as tall as the bottle neck.

Tips and Techniques

Make a Paper Stumpy with Your Napkin.
This handmade tool will help you blend and smooth this **shading**-intensive drawing.

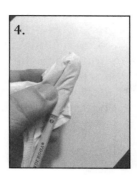

▶ Fold your (paper) napkin in half, and wrap it around the eraser end of your pencil as shown (Figure 4).
▶ **Or** twist your paper napkin into a lumpy wedge (Figure 5).
▶ **Or** forget the napkin and use your finger. It works great, but I wouldn't recommend it if you're drawing at a restaurant, unless you want to ingest a little graphite with your pasta.

Stumpy Techniques
Think of the stumpy as a kind of paintbrush. You can avoid pencil lines by loading it with "color" (graphite) and using it to shade your drawing. (Practice your techniques on the sides of your paper.)

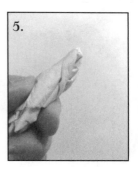

▶ To shade white areas adjacent to areas you have already shaded, place the stumpy on the shaded areas and move it back and forth across the white area (go back to the shaded area to pick up more color) (Figure 6).
▶ Or create a dark scribble on the side of your drawing and rub the stumpy in this pencil puddle to pick up residual graphite.

> **Have fun with shading.** *In my final wine bottle drawing (page 102) I took some liberties with blended* **shading** *to make the shape look more round.*

DRAW THAT WINE BOTTLE!

1. Draw Your Blueprint
5 minutes!

Draw lightly!

1.

▶ Draw the basic shapes in the bottle—the circle, the large rectangle (bottle body), and the smaller rectangle (bottle neck).
▶ Add lines to show the bottoms of the bottle cap and foil wrapper (Figure 1).

2. Shape the Shapes
5 minutes!

▶ Erase the extra lines.
▶ Add three rectangular areas of reflection (Figure 2).

2.

3. See the Light
15 minutes!

Notice where the light strikes this image.

3.

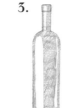

▶ Shade the whole bottle lightly twice—*except the reflections* (Figure 3).
▶ Shade the whole bottle lightly a third time—and *this time include the reflection area in the foil wrapper* (Figure 4).
▶ Use your stumpy or finger to add the shadow under the bottle (Figure 5).
▶ Darken the edges and bottom of the bottle as well as the area under the bottle cap. Widen the bottle top (Figure 5).

4.

5.

4. Finish Up!
5 minutes!

6.

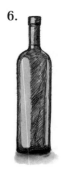

▶ Lightly shade all remaining reflections with your stumpy or finger (Figure 6).
▶ Erase the **highlights** (Figure 7).
▶ Round any remaining square edges, and darken edges where needed (Figure 7).

Cheers! A toast to you, my artist friend.

7.

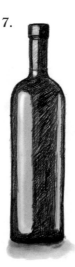

YOUR DRAWING PAGE

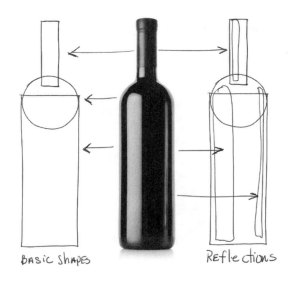

Basic Shapes

Reflections

BONUS CHALLENGE: WINE GLASS

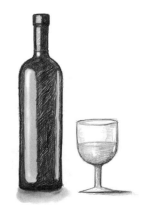

You've got your wine bottle drawn. Now, here's a glass so you can enjoy it. We'll use the same basic shapes we used in the wine bottle to get started. *Draw lightly— you'll be erasing extra lines.*

1. Draw a circle in the middle of your page; trace a quarter if you wish (Figure 1).
2. Draw a rectangle with the same diameter as the circle, over the circle as shown (use your credit card as a guide as we did on page 100) (Figure 2).
3. Draw a stem within your rectangle, not quite to the bottom of the rectangle (leave room for the glass bottom) (Figure 3).
4. From the bottom of each side of your stem draw lines angled to each lower corner of the rectangle (Figure 3).
5. Draw a skinny oval near the top of the rectangle and a skinny oval at the top of your original circle (Figure 4).
6. Erase the extra lines as shown (Figure 5).
7. Choose your **light source**, and draw it on your paper. Shade everywhere the light doesn't hit, including the interior of the class (Figure 6). You can use your stumpy (page 6) to keep your shadows smooth.
8. To anchor the glass to the ground, add a small, dark shadow extending from the bottom and away from the light source. Darken the darkest spots once again (especially the edges), and continue to play with the shading. Erase a highlight and take a sip! (Figure 7).

1.

2.
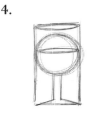

3.
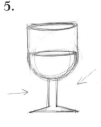

4.

5.
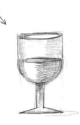

6.

7.
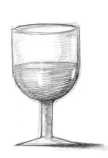

LESSON 17

30-MINUTE TREE FROG

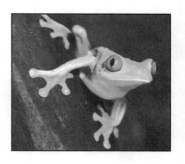

One morning I woke up to find a little fellow, just like the guy in this photo, chillin' outside my kitchen window. The frog was my favorite color of emerald green and smaller than my thumb. I spilled my coffee grabbing my iPhone to take a photo. It was worth the mess! I try to photograph at least one thing a day to remind me of things I want to draw. A frog, a cloud, a tilted mailbox—cool inspirations are everywhere once you get in the habit of sketching for 30 minutes a day!

For this lesson I give big thanks to the amazing artist Rod Thornton! I'm honored to claim Rod as my good friend and a true inspiration. Rod is arguably one of the finest comic illustrators on the planet. He's a freelance artist and has worked on illustrations for DC Comics, Red5 Comics, and *Children of the Apocalypse*, published by Angel Comics.

Not only has Rod spent scores of hours helping me with the illustrations for this book; he also graciously agreed to be one of my guest artists, developing this tree frog drawing lesson just for you! To see more of Rod Thornton's *amazing* artwork, visit www .angelcomicsonline.com, and look for him at Comic Cons across America and Europe.

LOCATION
My friend Rod and I drew this frog in his kitchen.

TREE FROG DRAWING TOOLS

- ▶ Pencil
- ▶ Eraser
- ▶ Paper to draw on—or use the practice page 109

- ▶ Quarter
- ▶ Dime
- ▶ Square refrigerator magnet

TODAY'S TREE FROG

Placement is everything in this drawing.

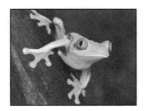

SHAPES IN A TREE FROG

DECONSTRUCTED TREE FROG

Before You Begin . . .
Read these two pages.
No drawing yet!

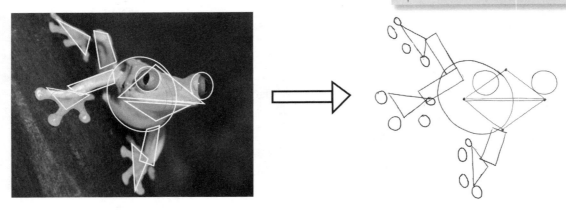

Croak! Looks complicated, right? I promise you'll be able to place this gorgeous critter on your own page, real enough to hop off, in less than 30 minutes. You'll first create your **blueprint** by deconstructing our little frog here into its basic shapes. He is made up of triangles, circles, rectangles, and an oval. He just looks difficult to draw because there are so many little shapes. We'll make things easy by drawing the blueprint in two stages.

30-MINUTE TREE FROG HACKS

Shape Stacking

In complicated drawings I sometimes determine where the basic shapes go by drawing dots on the page as points of reference. I call these dots **anchors**. I also stack the shapes on the page relative either to these anchors or to each other.

How to Shape Stack the Head

1. Pop a dot in the middle of your paper. It's the primary **anchor dot** (Figure 1).
2. Put a quarter next to the dot, a bit to the side, as a point of reference. Draw three more dots around the quarter. The side dots are farther from the quarter than the top and bottom dots (Figure 1).
3. Remove the quarter. Connect the dots to draw the two triangles of the frog's head (Figure 2).
4. Trace a dime to hack the first eye. It intersects the line of the top triangle between the **anchor dot** and the triangle's top (Figure 3).
5. The outside eye (trace the dime again) sits on the opposite side of the triangle (Figure 3).

1.

2.

3.

Stack the Back Arm and Leg

1. In the photo do you see how the frog's back arm and leg pretty much form a right angle? Hack their positions by tracing a right-angle guideline. Place anything with a corner—like a square fridge magnet—next to the eyeball above one of the **anchor dots** (Figure 4).
2. After you move the magnet, draw the rectangle for the arm first, and then stack the rectangle for the leg directly above (Figure 5).

Stack the Front Arm, Feet, and Toes

To place your shapes, look for relative positions:

▶ The front arm rectangle stacks directly below the bottom dot of the bottom triangle.
▶ The feet triangles stack next to the rectangles.
▶ Two toe circles on each foot connect to the triangle feet corners (Figure 6).

Measuring Shortcuts

▶ If you use a quarter to anchor the frog's mouth, the oval is about two quarters in diameter (the frog's body is about twice the **size** of his mouth).
▶ The frog's eyes are each about a third the size of his mouth.
▶ If you used a quarter as an anchor, the length of each of the arm/leg rectangles is about the diameter of that quarter.
▶ Here's a surprise: the feet are just about as long as the legs (also about the diameter of a quarter).

4.

5.

6.

DRAW THAT TREE FROG!

1. Blueprint Your Frog Head and Body

5 minutes!

Draw lightly!

▶ Employ the hacks and stacks from the previous pages if you like.

▶ Draw the two triangles for your frog's mouth (Figure 1).

▶ Draw two circles for the eyeballs (Figure 1).

▶ Lightly add the oval shape of the frog's body. It's on an angle, intersecting your triangles as shown (note that one whole eyeball stays inside the oval) (Figure 2).

1.

2.

2. Blueprint Your Frog Arms, Leg, and Toes

5 minutes!

▶ If you like, use the hacks and stacks from the previous pages.

▶ Draw the three rectangles for the arms and leg.

▶ Draw the three triangles for the feet.

▶ Draw the four small circles on each foot (Figure 3).

3.

3. Shape the Shapes

10 minutes!

▶ Connect the toes to the feet (Figure 4).

▶ Erase the extra lines and dots in the feet, arms, legs, eyes, and inside lower jaw (Figure 5).

▶ Curve the legs and mouth.

▶ Connect the far eyeball to the top of the head; smooth the top of the head triangle (Figure 6).

▶ Pop a diamond shape in the middle of the near eye.

▶ Divide the other eye in half with a semicircle; add a pupil.

▶ Add a defining line next to the inner eye, on the back leg, and under the jaw (Figure 7).

4.

5.

6.

7.

4. See the Light

10 minutes!

Notice where the light strikes this image.

▶ Outline the shapes of all the **shadows** you see, then fill them in (Figure 8).

▶ Darken the darkest spots, and add defining dark lines to the outside edges of your frog (Figure 9).

▶ Put your frog on a branch if you want! Give him shadows under his body and under his toes (Figure 10).

8.

9.

10.

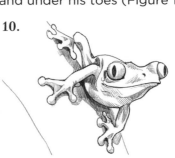

YOUR
DRAWING
PAGE

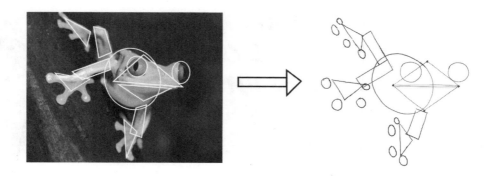

BONUS CHALLENGE: USE YOUR EYE TO FIND MORE SHAPES

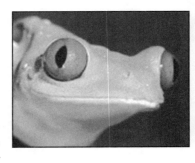

When we're sketching for speed, we don't have time for perfection; in fact, I'm all for imperfect, personality-filled drawings! Our 30-minute frog was impressive. But if you have more time, you can make him even more realistic and lifelike. How? Use the same techniques, just zoom in! Find the frog's subtle shapes, and place them relative to one another on your page.

Let's go back to the tree frog head **blueprint**.

1. Do you see how the inside eyeball actually has a semicircle-shaped eyelid on the top of the head? And next to the eyelid there's a semicircle-shaped bump, a crevice, and another bump? There's also skin halfway across the shape for the outside eyeball. Add them (Figure 1).

Fun Frog Fact: Frogs' eyelids close from the bottom up.

2. You can make your frog look reptilian by defining the shape of the mouth more closely and adding a simple nostril.

 ▶ Draw new "V" shapes—one at the outside edge where the "lips" meet and another a little ways into the mouth as well as that nostril above and a little to the left of the "V" on the mouth.
 ▶ The mouth curves more subtly than in our quick sketch, so adjust based on what you see (Figure 2).

3. With more time we can add more gradation to the shadows. This will cause the lower lip to emerge (note: erase the original triangle blueprint shapes) (Figure 3).

4. See the texture of the frog's skin in the shadows under both eyes? The scales are shaped like a "C." Add a few to make the frog more lifelike. Add the pupils as well (Figure 4).

The longer you look at the frog photo, the more shapes, shadows, and textures you'll see. Although our goal is pleasure, not perfection, adding just a few of these details can make a big difference.

1.

2.

3.

4.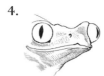

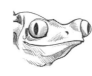

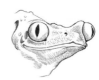

30-MINUTE DICE

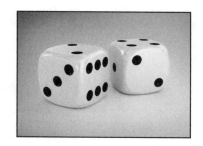

This image sends me back to one memorable New Year's Eve in Vegas when I spent the evening copying my friend Jonathan's bets. I'm lucky he's much smarter than me because I won back the price of my hotel room! Dice are cube shaped, obviously, and cubes are an important shape to learn to draw. I love 'em; I doodle cubes everywhere. But the trickiest part of this drawing isn't the basic shapes; it's getting the **perspective** down: drawing these cubes so that they look three dimensional and ready to roll across that craps—I mean Yahtzee—table.

LOCATION
I'm drawing these dice in my hotel room.

DICE DRAWING TOOLS

- ▶ Pencil
- ▶ Eraser
- ▶ Paper to draw on—or use the practice page 115
- ▶ Hotel room key
- ▶ Hotel notepad
- ▶ Tissue

TODAY'S DICE

I bet drawing these dice will be as much fun as rolling them—and more of a sure thing!

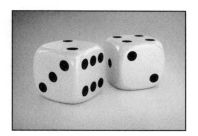

SHAPES IN DICE

DECONSTRUCTED DICE

Before You Begin . . .
Read these two pages.
No drawing yet!

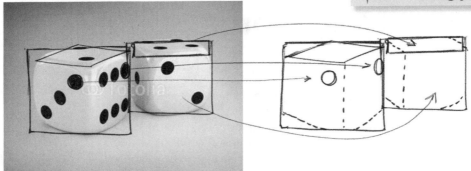

Each individual die is a big square—see it? Now look for the shapes within the squares—a skinny rectangle on the top of the smaller die, a diamond on the top of the larger one. We'll eventually add parallel lines here and there to give the squares **dimension**. The "pips" (yes, there's actually a name for these dots on dice) are circles that become ovals as they move back in space.

30-MINUTE DICE HACKS

A couple of simple ways to hack a square:

Make a Square from a Rectangular Piece of Paper

1. Fold the bottom corner of the paper to form a triangle (Figure 1).
2. Crease and tear off the part of the paper that isn't in the triangle; unfold (Figure 2 and Figure 3).

Or Hack a Square with Your Room Key

Use your hotel room key as a template for three sides of your square. Using the short side of your key to measure, make the top and bottom the same length as the short side, then add the final side. *Use your room key to guide all your straight lines* (Figure 4).

Draw Your Diamond with Dots

Draw (freehand) four dots on your **blueprint** square where you think the corners of the top diamond shape will be. The visual will help! (Figure 5).

5.

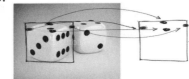

MEASURING SHORTCUTS

On the die in front, the line down the middle of the die looks like it's about halfway across—but it's actually about two-thirds the way across (Figure 6)! (Check with the "pencil-measure" hack, page 6.)

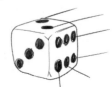

6.

TIPS AND TECHNIQUES

Dice Pip Tips

The pips (the black circles on dice) on the sides closest to us look like the circles they are. As they move back in space they look flatter and smaller. Squishing circles gradually into ovals will make your die look three dimensional.

7.

The pips on the top of each die are pretty flat ovals. The ones in front are clearly circles (Figure 7).

For the six-pip side, make the nearest pips circles, the farthest pips ovals, and the others somewhere in between. Remember, we're not aiming for *perfection*; we're aiming for *impression*.

Drawing White on White

White objects on a light background can be confusing to draw. Try this:

1. Use dotted or light lines to identify the edges of each die. You'll eventually erase some of the lines (and fill in others), but these guides will help position other basic shapes and guide your **shading**.
2. The dice pop when the background is gray. Your dice drawing will look much more "finished" when you add background shading.

DRAW THOSE DICE!

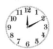 **1. Draw Your Blueprint**

10 minutes!

Draw lightly!

1.

- ▶ Draw two squares (Figure 1).
- ▶ Draw a diamond on top of the larger die and a skinny rectangle on top of the smaller die (Figure 2).
- ▶ Draw dotted lines to indicate the edges of the dice, as shown (Figure 3).
- ▶ Erase the extra lines (Figure 4).

2.

3.

4.

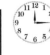 **2. Dot the Dice**

5 minutes!

- ▶ Draw flat ovals for pips on the tops of each die.
- ▶ Draw circles for pips closest to front.
- ▶ Draw fat ovals for pips farthest from front (on the sides).
- ▶ Fill in the six-pip side with gradations between oval and circle (see page 113) (Figure 5).

5.

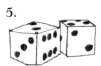

 3. See the Light

10 minutes!

Notice where the light strikes this image.

6.

7.

8.

9.

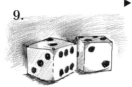

- ▶ Draw the darkest **shadows**, which are on the left side of the smaller die and underneath each die (Figure 6).
- ▶ Add a shadow along the top and center edges as well as parts of the tops, sketching *over* the bright spots and **highlights** (we'll erase them later) (Figure 7).
- ▶ Erase highlights (Figure 8).
- ▶ Darken the edges, and sketch in some background; feel free to vary the shade. In fact, there are fifty *thousand* shades of gray! (Figure 9).

4. Finish Up!

5 minutes!

- ▶ Round the sharp corners.
- ▶ Blend the shading with your finger or a tissue to get a smooth, shiny feel.
- ▶ Blacken the pips (Figure 10).

10.

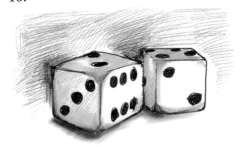

YOUR DRAWING PAGE

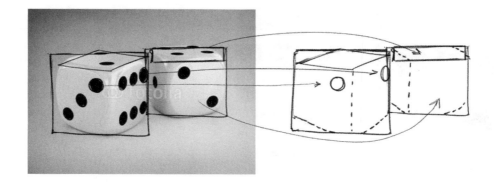

BONUS CHALLENGE: PLAY WITH YOUR BLOCKS

When I draw from my imagination I use cubes as building blocks for elements of the drawing to create the illusion of depth. Buildings, trees, and even people can be built from cubes. We used the "basic shapes" technique to get the dice cubes onto your paper quickly. Now try drawing cubes using the following technique:

1. Draw two dots on your paper straight across from each other (Figure 1).
2. Put your finger in between the two dots. Draw two more dots above and below your fingertip (Figure 2).
3. Connect the dots to create a **foreshortened** (squished) square (Figure 3).
4. Draw three vertical lines down from each side and the center (as shown), making sure the center line is a little longer than the lines on the sides (Figure 4).
5. To draw the bottom of the cube, draw lines that are angled just like the lines that show the top edges of the cube (Figure 5).
6. Choose a **light source**, and shade the opposite side. Make sure to add a dark shadow extending out from the bottom and away from the light source to anchor the cube on the ground. Make sure the shadow follows the same angle as the line marking the bottom of the cube nearest the shadow (Figure 6).

Drawing brings out the joyful child in all of us! Let's spend some time playing with blocks. Have fun drawing stacked cubes as doodles, warm-ups, finished pieces, or as the basis of a more complex drawing (Figure 7).

1.

2.

3.
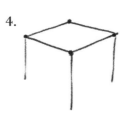

4.

5.
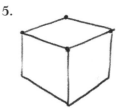

6.
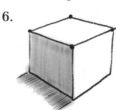

7.

30-MINUTE BLENDER

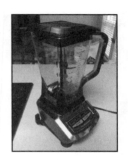

I love making smoothies, and I'm always thinking about art. So guess what crossed my mind as I rinsed off a bunch of carrots to prep them for pulverizing in my awesome, turbo-charged, million-RPM, cold fusion–powered blender? You got it. A blender is a great subject for a 30-minute drawing! It looks really hard to draw but can be sketched quickly when broken down into basic shapes and, of course, hacked.

I'm constantly reminded how important drawing is when it comes to designing the world in which we live. This blender is a perfect example of functional art. I see my totally boss Ninja blender as a prized "kitchen sculpture," and I never stop admiring the creative people who designed it.

LOCATION

I'm drawing in my kitchen next to my jet rocket–propelled Ninja blender.

BLENDER DRAWING TOOLS

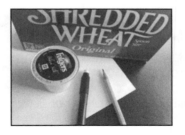

- ▶ Pencil
- ▶ Eraser
- ▶ Paper to draw on—or use the practice page 121
- ▶ Keurig K-Cup coffee pod
- ▶ Cereal box

TODAY'S BLENDER

Yes, you can draw a blender in 30 minutes!

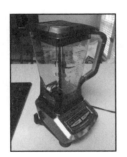

SHAPES IN A BLENDER

DECONSTRUCTED BLENDER

Before You Begin . . .
Read these two pages.
No drawing yet!

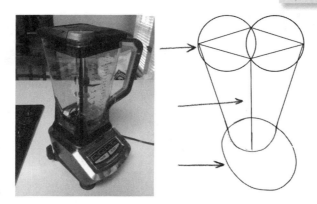

I draw **holding circles** to help me quickly place the basic shapes comprising the blender. In fact, I sketch circles pretty much everywhere in this drawing—and then erase them all. You may notice also that I draw the lid of the blender as a diamond. When you look at it straight on, it's actually square shaped. The diamond shape is an illusion created when the blender lid is tilted down almost flat and viewed from a distance.

30-MINUTE BLENDER HACKS

I'm thinking of marketing the Keurig K-Cup coffee pod as a new, all-purpose drawing tool! I use it to hack the whole blender—and to fuel me with dark-roasted coffee while I draw. Thirty-minute drawing is all about using the tools at hand to get that drawing onto the page.

1.

K-Cup the Diamond-Shaped Blender Top

Draw holding circles and lines to place the diamond-shaped blender lid.

2.

1. Lightly draw a **holding line** by tracing the edge of a cereal box a few inches from the top of your page (Figure 1).
2. Lightly trace the small end of a K-Cup twice, placing two intersecting circles on the line as shown (Figure 1).
3. Draw dots where the circles intersect and about halfway up the outside of each circle (Figure 2).
4. Connect the dots to draw the blender lid diamond (Figure 3).

3.

The vertical line down the center of the jar is the most important line in the drawing!

K-Cup (and Cereal Box) Hack for the Blender Jar

1. Measure two K-Cups (large side) down from the diamond's bottom dot, and draw a mark. Draw a straight line that ends at your mark, using the vertical dots on your diamond as guides (Figure 4).
2. Trace the bottom of the K-Cup to make a holding circle at the bottom of the blender jar. Pop guide dots roughly halfway up each side of the holding circle, and darken the bottom half of the circle between the dots (Figure 5).
3. Draw straight lines between the dots for the sides of the jar (Figure 6).

K-Cup Hack for the Oval-Shaped Base

1. Place the K-Cup, large side down, between the dots at the bottom of the blender.
2. Move the K-Cup to the right and down a smidgen, then trace again (Figure 7).
3. Darken the edge around the two intersecting circles to create a tilted fat oval for the blender base (Figure 8).

Use a **smudge shield** (see page 5)!

4.

5.

6.

7.

8.

TIPS AND TECHNIQUES

Jump-Start the Base by Drawing the Faceplate

Place dots on the big oval where the sides of the faceplate would land if they extended to the edge of the oval. Draw light lines from the tips of the diamond on the blender bottom almost to your dots (leave space for the front of the blender) (Figure 9).

Now draw the bottom of the faceplate (Figure 10). Position the other parts of the base relative to the faceplate.

9.

10.

DRAW THAT BLENDER!

 1. Draw Your Blueprint

10 minutes!

Draw lightly!

1.

- Draw the diamond-shaped blender top (see hacks, page 118) (Figure 1).
- Draw the blender jar (see hacks, page 119) (Figure 2).
- Draw the chubby, tilted oval for the blender bottom (see page 119) (Figure 3).

2.

3.

 2. Shape the Shapes

10 minutes!

- Erase the lid's holding circles and lines.
- Add the lid's bottom edges, extending a little outside the jar (Figure 4).
- Draw the jar-bottom diamond (Figure 5).
- Add the faceplate shape (see page 119) (Figure 6).
- Add the base front and the two feet, and adjust the edges (Figure 7).
- Erase everything that's not your blender (Figure 8)!

4.

5.

6. **7.** **8.**

 3. See the Light

5 minutes!

Notice where the light strikes this image.

9.

- Darken (or add) the parts of the blender that are dark in color (Figure 9):
 - The lid and lid sides
 - Center blade
 - Inside bottom of the jar
 - Base face
 - Blender feet

10.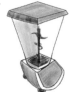

- Darken those parts of the blender that are farthest away or in **shadow**.
- Erase the brightest reflections (Figure 10).

 4. Finish Up!

5 minutes!

- Sketch the handle—no need for perfection. Make sure to darken the parts in the shade.
- Sketch the faceplate buttons as rough shapes that slant up (Figure 11).
- Darken the shadows below the center and a bit left of the blender body and feet to make your blender appear to sit firmly on a surface.
- Erase extra lines, and have a smoothie! (Figure 12).

11.

12.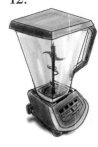

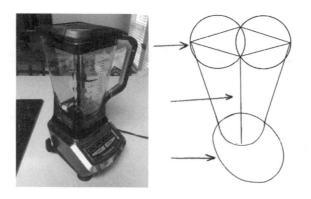

BONUS CHALLENGE: BLENDER MADNESS!

Okay, I'll admit it: that was a pretty intense 30-minute drawing. So for this bonus let's just have some fun! We're going to make an endless field of blender shapes, and in the process practice creating the illusion of depth and distance. Take your time and play with this one—the repetition is relaxing.

1. Draw a frame on your page—trace it, dot it, whatever you like (Figure 1).
2. Draw a row of three diamonds, each about the same **size**, about a third of the way up from the bottom of your frame (Figure 2).
3. Draw the center lines straight down from each diamond's front bottom point. Now draw the lines that begin on the side points of your diamonds. **Taper** those lines in as shown, drawing all the way down to the bottom of the frame (Figure 3).
4. Draw another row of smaller diamonds, as shown (Figure 4).
5. Add center lines and tapered lines to the new diamonds, leaving out the parts blocked by the shapes in the front row (Figure 4).
6. Continue to add rows. Each diamond in each new row is between the diamonds in front of it, and each new row is a little smaller, sketchier, and more populated (Figure 5).
7. Determine the **light source**, and add **shading**.
8. Bring your drawing to life by darkening and defining the spots where the shapes **overlap** (Figure 6).

1.

2.

3.

4.

5.

6.

30-MINUTE TEDDY BEAR

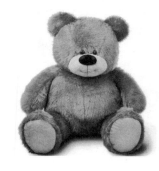

The teddy bear is probably the most universal icon of cuddly love, hugs, and happiness. I love drawing them! I've drawn teddy bears in almost every one of my books, on all my TV series, and on my YouTube channel videos. Draw a few, and see how quickly you catch the teddy bear bug!

LOCATION

I'm drawing this teddy bear at the Comicpalooza in Houston, Texas's very own international comic convention—a massive event!

TEDDY BEAR DRAWING TOOLS

▶ Pencil
▶ Eraser
▶ Paper to draw on—or use the practice page 127
▶ Cup
▶ Nickel
▶ Dime

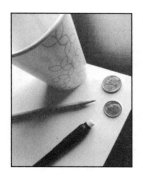

TODAY'S TEDDY BEAR

Awwwwwwww.

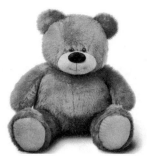

SHAPES IN A TEDDY BEAR

DECONSTRUCTED TEDDY BEAR

Before You Begin . . .
Read these two pages.
No drawing yet!

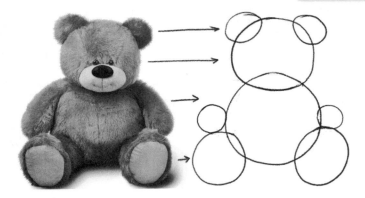

Shake out your drawing hand and loosen that wrist—there are lots of circles in this soft, round teddy! I see eight basic circle shapes: the head, the body, the feet, the paws ("hands"), and the ears. The snout and the nose are oval shaped.

30-MINUTE TEDDY BEAR HACKS

Big Circle, Little Circle

Trace any circular object that looks about two inches in diameter for the teddy's body. I used the bottom of a paper cup; you can use a cup, a soda/pop can, or even a K-Cup coffee pod (Figure 1).

The teddy bear's head **overlaps** the body and is just a little smaller than the body. If you can't find a slightly smaller circular object to trace, hack the head by tracing the same object you used for the body as a guiding circle. Draw the smaller circle within the larger circle freehand (Figure 2).

1.

Nickels and Dimes

Trace a nickel for the feet circles and a dime for the ears and hands.

MEASURING SHORTCUTS

2.

▶ The feet circles only slightly **overlap** the big body circle. Most of the feet circles extend below and to each side of the teddy's body circle.
▶ The feet circles are about as far apart from each other as the teddy's snout is wide.
▶ The hand circles rest on top of the feet circles.
▶ Each foot circle is about half the **size** of the head circle.

TIPS AND TECHNIQUES

Shading Matters

Getting the nooks and crannies where shapes overlap really dark will define the shape of this otherwise soft fellow. There are lots of key places to darken in this drawing (Figure 3):

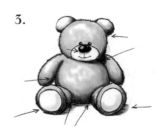

3.

- ▶ Between the ears and the head
- ▶ Under the nose
- ▶ Between the head and the body
- ▶ Between the arms and the body
- ▶ Where the legs meet the body
- ▶ Between the left foot and the left leg
- ▶ Around the pads of the feet
- ▶ Where the feet and the body touch the surface below.

How to Make Fur Look "Furry"

Draw the fur outlining the teddy bear with random strokes, with some tufts bigger than others and some even moving in different directions (Figure 4). Avoid being too stiff or regular, or your teddy bear may look like it got struck by lightning (Figure 5) . . . or grew out of a cactus (Figure 6). Artists sometimes call this **planned randomness** or **organized chaos**.

4.

5.

6.

DRAW THAT TEDDY BEAR!

1. Draw Your Blueprint
5 minutes!

Draw lightly!

1.
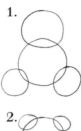

▶ Draw circles for the bear's body and head, using hacks from previous pages if you wish. Add the feet (Figure 1).

▶ Hack or sketch in the ears and hands (Figure 2).

2.
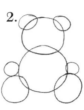

▶ Draw the oval-shaped snout and nose (Figure 3).

3.
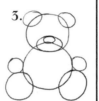

2. Shape the Shapes
10 minutes!

▶ Draw the arms/shoulders as shown (Figure 4).

▶ Angle the feet outward, and smoosh the feet circles (Figure 5).

▶ Add semicircles for the legs as shown (Figure 6).

▶ Erase the original **blueprint**. Draw in the bear's eyes (Figure 7).

4.
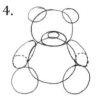

5.
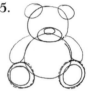

6.
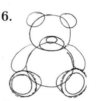

7.
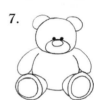

3. See the Light
5 minutes!

Notice where the light strikes this image.

▶ Shade the side opposite the light (Figure 8).

▶ Shade the darkest darks, and a **cast shadow** where the teddy bear touches the surface (Figure 9).

8.

9.

4. Finish Up!
10 minutes!

▶ Darken the nose, leaving white the two **highlights**.

▶ Erase highlights in each eye.

▶ Draw in the mouth (Figure 10).

▶ Sketch in fur around the edges of the drawing and where parts overlap.

▶ Add additional **shading**, and blend with your finger (Figure 11).

10.
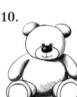

11.
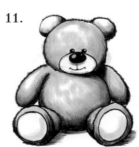

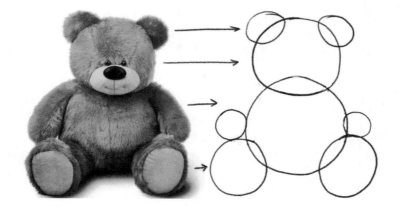

BONUS CHALLENGE: THE UNIBEAR

One of the most popular characters in my 1980s PBS children's television series *The Secret City* was my "unibear," a fantastical combination of a teddy bear and a unicorn. All these years later, during my travels to comic conventions around the world, the best-selling of all my autographed author prints is the . . . can you guess? The unibear. This fun character is also my most requested commissioned pencil sketch. Save yourself $300 and draw your own little unibear dude right here, right now!

1. Blueprint the bear's circular body and slightly smaller head (Figure 1).
2. Add the ears, legs, and circles for the hand areas.

 ▶ The legs are about the same length as the diameter of the head (Figure 2).
 ▶ Place the hand circles as shown; this will help you keep the arm size uniform (Figure 2).

3. Draw the arms and face. Draw the squiggly unicorn horn about as tall as the head and body together. Erase the blueprint lines (Figure 3).
4. Notice your **light source**. Shade the areas opposite the light source. Darken most the hidden and overlapping places—under the chin, under the belly, and so forth. **Cast shadows** under the feet (Figure 4).
5. Add fur and additional shading. Smooth out the shading (Figure 5).

1.

2.

3.
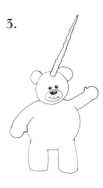

4.
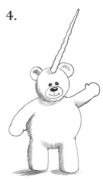

5.
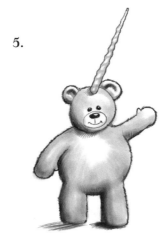

LESSON 21

30-MINUTE GROCERY BAG

It's just as satisfying—and just as much "art"—to draw an everyday item like a grocery bag as it is to draw some idealized classical object. I think the creases and **shadows** in this grocery bag are awesome! Take a look around you—instead of seeing a "pillow" or "water faucet" or "cat," notice the shapes and shadows they're each made of. You don't need a fancy studio or an ocean view; great subjects are everywhere.

Big thanks to my artist friend Rosel Rodriguez for jumpstarting this grocery bag lesson. I loved his idea for mapping the shadows! You can check out Rosel's art at www.freelanced.com /roselrodriguez.

LOCATION

I'm drawing this in my kitchen when I should be putting away the groceries.

GROCERY BAG DRAWING TOOLS

▶ Pencil
▶ Eraser
▶ Paper to draw on—or use the practice page 133
▶ Credit card
▶ Your pinky finger

TODAY'S GROCERY BAG

Reuse, recycle, redraw!

SHAPES IN A GROCERY BAG

DECONSTRUCTED GROCERY BAG

Before You Begin . . .
Read these two pages.
No drawing yet!

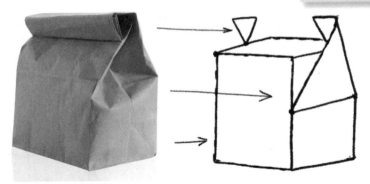

The deconstructed paper bag looks a little like a one-eared robot, doesn't it? Look a while longer and you'll see the basic box and triangle shapes of the grocery bag in the photo. A grocery bag is in fact a **cuboid** shape. (What a great word! That's what a rectangular cube is called.) Drawing boxes is almost as fun as saying "cuboid." To create the grocery bag **blueprint** I draw the cuboid, then place the triangle shapes relative to the box I've just drawn. Later I revise the shapes a little to get the **perspective** right, and finally, I create a map of the shadows that provide the illusion of crinkles and depth. Warning: there's lots of erasing in this 30-minute drawing!

Don't hesitate to sketch this blueprint freehand instead of using hacks. You might surprise yourself!

30-MINUTE GROCERY BAG HACKS

Credit Card Place-and-Trace

Hey, I just went shopping. Might as well get a little more use out of my credit card.

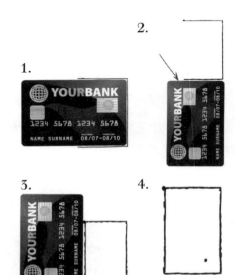

▶ Trace the short side of a credit card and about halfway across each of the longer sides to begin the front rectangle of the bag's **cuboid** shape (Figure 1).
▶ The top and bottom lines are about a pinky shorter than the short side of the credit card. Draw guide dots to help you measure (Figure 2).
▶ Connect the dots to complete the rectangle (Figure 3).
▶ Draw a guide dot to place the back rectangle: it's about one pinky width above the bottom line of the first rectangle and one pinky width inside the adjacent vertical line (Figure 4).

- Use your credit card to place and trace the second rectangle (the same **size** as the first) using the guide dot as its lower left corner (Figure 5).
- Connect all the corners to make a cube shape, using your card to make straight lines. I've dotted the hidden lines we will eventually erase (Figure 6).

Triangle Placement

- To place the triangles, draw an **anchor dot** about halfway across the tops of the cuboid sides.
- Add a dot about halfway down the vertical side of the front rectangle as shown (Figure 7).
- With the dots as a guide, trace the short end of your credit card to draw the first line of the big triangle (Figure 8).
- Complete the big triangle (Figure 9).
- Tuck in the little upside-down triangle next to the big one, and draw a matching little triangle across the way (Figure 10).

5. 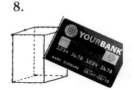 6.

7. 8.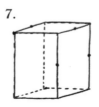

9. 10.

MEASURING SHORTCUTS

Relative placement is important in this drawing!

- The small triangles of the top folds of the bag each begin about halfway across the side rectangle tops.
- The side of the grocery bag is almost as wide as the front.
- The small upside-down triangles are about the size of your pinky if you use the credit card hack to size the cuboid.
- The "pencil-measure" hack (see page 6) is a handy tool to place the triangles and shadow map in this drawing.

TIPS AND TECHNIQUES

Map the Shadows in Your 3D Grocery Bag

In this 30-minute drawing I sketch the basic shapes of prominent shadows to give myself a "map" before **shading**. Here's a breakdown of the shadows I see. Hey, they're all triangles but one (Figure 11)!

11.

> *This drawing changes almost magically when you erase the extra lines in Step 2, Shape the Shapes. I love the way that happens!*

DRAW THAT GROCERY BAG!

 1. Draw Your Blueprint

10 minutes!

Draw lightly!

 1.

- ▶ Hack or sketch a rectangular cuboid.
- ▶ Erase the lines on the back of the cube.
- ▶ Draw a large triangle for the side indentation.
- ▶ Draw two small upside-down triangles for the rolled-down bag top (Figure 1).

 2. Shape the Shapes

5 minutes!

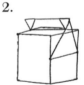 2.

- ▶ Connect the tops and bottoms of the small triangles (Figure 2).
- ▶ Erase the extra lines (Figures 3 and 4).
- ▶ Add two lines as shown to correct perspective and shape (Figure 5).
- ▶ Erase extra lines; refine as needed (I increased the angle of the line under the top of the fold in my drawing) (Figure 6).

3.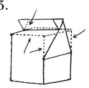

4. 5. 6.

3. Map the Shadows; See the Light

10 minutes!

Notice where the light strikes this image.

7.

- ▶ Map the large shadows using basic shapes (Figure 7).
- ▶ Leaving the lightest areas white—the top of the bag fold-over, the edges around the big triangle—shade the mapped areas (Figure 8).
- ▶ Shade the darkest darks and other areas not mapped (Figure 9).

8.

9.

4. Finish Up!

5 minutes!

- ▶ Add definition where needed; erase any smudges.
- ▶ Add thickness to the top of the fold.
- ▶ Add a **cast shadow** to make the bag pop off the page (Figure 10).

10.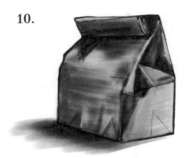

YOUR
DRAWING
PAGE

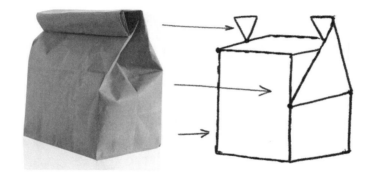

BONUS CHALLENGE: BOXES GALORE!

Cubes—and **cuboids**—are so much fun to draw. Let's draw some more, this time making a cube pyramid by using a different cube-drawing technique.

1. Draw two dots an inch or two apart. Draw two more dots in the middle of the first two as shown (Figure 1).
2. Connect the dots to form a squished diamond—also called a **foreshortened** square (Figure 2).
3. Draw lines extending down from the three lowest dots on the page; the middle line is longest (Figure 3).
4. Finish the cube by drawing two lines for the cube bottom, matching the angles of the lines above (Figure 3).
5. Draw the tops of the next level of cubes by following the direction of the lines already drawn, including the invisible lines on the back bottom of the cube (Figure 4).
6. Complete the new cube tops (Figure 5).
7. Create cube sides by adding vertical lines; make sure the two middle lines (one for each new cube) are longest (Figure 6).
8. Decide where the light is hitting your cube sculpture, and shade the opposite side. Darken the darkest spots, especially where the cubes **overlap**. Add **cast shadows**. See how shadows are cast on the ground *and* on the top of the lower cube away from the light (Figure 7)?

1.

2.

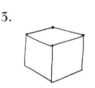

3.

4.

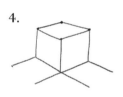

5.

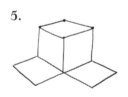

6.

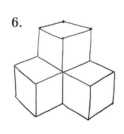

7.

LESSON 22

30-MINUTE WEDDING CAKE

I've been teaching drawing for over forty years to millions of students around the world on my PBS television series and on YouTube as well as through my drawing books. I must have drawn ten thousand cakes! Cakes are so much fun to practice drawing—there's an endless variety. When I searched online for pictures of wedding cakes I ended up spending a half-hour just enjoying the hundreds of splendid images. And I couldn't stop there. There are so many amazing, cool, crazy, creative cakes out there. I thought of my runner friend, whose birthday was coming up. Yep—lots of marathon runner–themed birthday cakes to draw. I went a little crazy trying to stump Google: Did you know that even "monkeys-in-a-bathtub birthday cake" is a thing? What fun ideas for your sketchbook!

LOCATION
I'm drawing this cake in my kitchen.

WEDDING CAKE DRAWING TOOLS

- ► Pencil
- ► Eraser
- ► Paper to draw on—or use the practice page 139
- ► Dollar bill (or thumb)

TODAY'S WEDDING CAKE

Let us draw cake!

SHAPES IN A WEDDING CAKE

DECONSTRUCTED WEDDING CAKE

✏ **Before You Begin . . .**
Read these two pages.
No drawing yet!

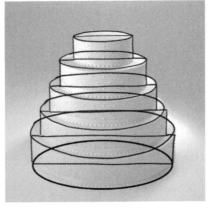 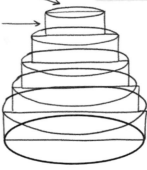

The basic shapes I see in this wedding cake are the oval and the rectangle, stacked and repeated. Piece of cake, right?! Wedding cakes—and cakes in general—are wonderful objects on which to practice blended **shading** on cylindrical shapes.

30-MINUTE WEDDING CAKE HACKS

Dollar Bill for Top Layer

This drawing starts with a stack of lightly drawn rectangles. Draw from the top (smallest rectangle) down.

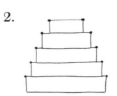

▶ Trace the short end of a dollar bill to sketch in the top and sides of that first rectangle. If you don't have a dollar handy, make the top rectangle the length of your thumb (Figure 1).
▶ Each rectangle (cake layer) cascading down is wider *on each side* than the previous one. Draw guide dots outside the bottom rectangle corners to mark the width of each rectangle before drawing it (Figure 2).

TIPS AND TECHNIQUES

Ovals!

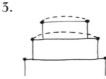

▶ After drawing the five stacked rectangles, surround the top and bottom of each rectangle in a slim oval (which means drawing *six* ovals!) Use your guide dots (see above) to draw the top curve of each oval, and then flip the paper to draw the oval's bottom curve. Most people find drawing lines that curve away more natural than drawing lines that curve toward them (Figure 3). (If you'd rather just draw freehand ovals all at once, go for it.)
▶ The bottom oval is as wide as the bottom of the bottom rectangle. Another way to think about it: the bottom two ovals are the same size.

Shading Details

The surface of this cake is very smooth. Mimic that effect by blending the shading on each layer with a store-bought or handmade stumpy (see page 6) (Figure 4).

Look closely at the photograph: notice how the tops of some layers are partly in the light and partly in the shadow? The light hits the *tops* of the layers in different spots than the *sides*. Leave those white spots white to make your drawing extra realistic (Figure 5).

Receding Beads

▶ The frosted beads at the *bottom* of each layer appear to be wider in the center and progressively narrower and closer together as they recede on the sides. This is a cool visual **distortion** that creates the illusion that the center of the cake is closer while the sides are farther away (Figure 6).

▶ On the *side* of each layer are three rows of frosted beads in evenly spaced patterns. The rows of beads aren't directly above each other; they alternate, creating patterns of three diagonal beads (Figure 7). These beads are also less visible and appear closer together toward the back of the cake. Drawing tips:

 ▶ You don't have to draw all the beads; *suggest* a cake covered with beads by drawing some and hinting at others (Figure 8).
 ▶ Add shadows and highlights to make the most visible beads pop (Figure 9).

4.

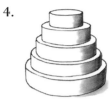

5.

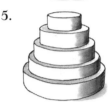

6.

7.

8.

9.

DRAW THAT WEDDING CAKE!

 1. Draw Your Blueprint

10 minutes!

Draw lightly!

▶ Draw five cascading rectangles (see hacks on page 136).
▶ Draw ovals around rectangle bottoms and tops (Figure 1).

1.

 2. Shape the Shapes

5 minutes!

▶ Erase all unnecessary lines.
▶ Refine where needed (Figure 2).

2.

 3. See the Light

10 minutes!

 Notice where the light strikes this image.

▶ Shade areas opposite the light, including the shadows on the tops of each layer (Figure 3).
▶ Further darken areas farthest away from the light; add a small **cast shadow** (Figure 4).
▶ Use a stumpy or your finger to smooth out shading (Figure 5).
▶ Draw a curved line near the bottom of each layer to indicate the decorative ribbon (Figure 6).

3.

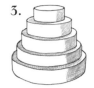

4.

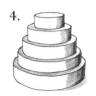

5.

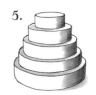

6.

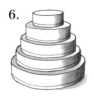

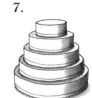 **4. Finish Up!**

5 minutes!

▶ Sketch in frosting beads along the bottom of each layer (see page 137) (Figure 7).
▶ Draw and shade decorative beads on the cake (see page 137). Erase highlights (Figure 8).

7.

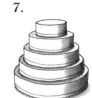

8.

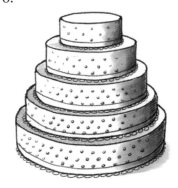

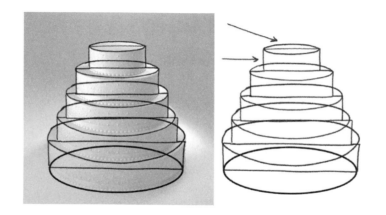

BONUS CHALLENGE: A PIECE OF CAKE

1.

We spent a half-hour drawing a cake—now let's enjoy a slice! To draw a simple cake with a piece missing, we'll use similar **blueprint** and **shading** techniques to those we used in our wedding cake.

1. Lightly draw a rectangle (trace the top of a dollar bill for length and sharp corners if you like), about two inches tall. Draw an oval around the top of the rectangle.
2. Draw dots outside each bottom corner. Use the dots as guides for your second oval shape (this will be the plate) (Figure 1).
3. Curve the line at the bottom of the rectangle. Erase the extra lines (Figure 2).
4. Draw a dot in the middle of the cake top oval and two dots on the cake top edge. This doesn't have to be exact—cake slicing never is! (Figure 3).
5. Connect the dots, and then draw straight vertical lines down from each edge dot to the plate. Erase interior lines (Figure 4).
6. Sketch in some gooey frosting and candles (Figure 5).
7. Decide where the light is coming from. Shade the areas on the cake, the candles, and the plate away from the light in the shadow. Include the area, hidden from the light, that has been sliced. Do a few more shading passes, especially darkening the areas where the frosting drips and the cake meets the plate. Yum (Figure 6)!

2.

3.

4.

5.

6.

30-MINUTE BOOK

I love to read. There's no TV in the living room of my house, but there are enormous built-in bookshelves surrounding the fire-place. My four siblings and I all owe our ferocious appetites for books to our mom. She churns through four or five books a week (seriously), while I read maybe two novels a week while sitting in my cozy living room. Books are almost as important in my life as art—sometimes I have trouble believing I've actually written a few myself!

LOCATION

I'm drawing this in my favorite red, lumpy, comfy chair in my book-filled living room.

BOOK DRAWING TOOLS

- ► Pencil
- ► Eraser
- ► Paper to draw on—or use the practice page 145
- ► Book
- ► Notebook paper
- ► Your thumb

TODAY'S BOOK

I'm drawing my first instructional book for adults, *You Can Draw in 30 Days*, here in my second instructional book for adults—there is something very M. C. Escher–esque about that!

SHAPES IN THIS BOOK

DECONSTRUCTED BOOK

✏ Before You Begin . . .
Read these two pages.
No drawing yet!

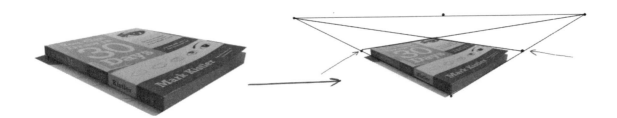

You might glance at the illustrations in this chapter and fear you need a course in advanced geometry to get it right. Trust me—it's much easier than it looks! Drawing a book shape quickly and realistically involves more *re*constructing than deconstructing. A book is more than simply a rectangle. Although it is true that the shape of a book held straight in front of our eyes is rectangular, the book in this photo is a distance away from us and lying flat on a surface. That position changes the rectangular shape. Consider that, and think about where the book fits in space. In my mind's eye I see the book sitting snugly inside the bottom of a giant triangle, defined by two skinnier triangles.

30-MINUTE BOOK HACKS

Vanishing Points: Placement and Perspective

Use the points of a giant triangle—again and again—to draw your book in realistic **perspective** (see page 146 to learn why this works).

1. Turn your drawing page so it's longer than it is wide. Use the edge of a book to draw the longest horizontal line that will fit on the page. This will be the top edge of your giant triangle (Figure 1).
2. Find the line's midpoint, and draw a dot. Hack this by measuring the line with another piece of paper, then folding that paper in half (Figure 1).
3. Place a dot about a thumb's length down from the midpoint dot (Figure 2); this will be the bottom of your triangle.
4. Draw dots on each end of the triangle's long top line. You'll be using these dots often in this drawing! (These dots are your **vanishing points**.) Complete the big triangle by connecting these dots to the dot on the bottom of your triangle (keep your lines straight by using a book or piece of notebook paper as a guide (Figure 3).

5. Now the fun starts! Draw a dot about a third of the way up one side of the triangle, where the book's bottom edge might end (Figure 3).
6. Create a triangle within your triangle by drawing a light line from this new dot to the vanishing point dot on the opposite end of the top line (Figure 3).
7. Pop a dot a little farther up the other side of the big triangle as shown, where the top edge of the book's spine would end (Figure 4).
8. Connect the new dot to the vanishing point dot on the opposite top line of the big triangle. See your book's basic shape, snuggled into the bottom of your big triangle? (Figure 5).

Hacked Book Sides

Hack the spine and bottom edge of your book by using the vanishing point guideline technique.

1. Draw a dot a short distance below your bottom dot.
2. Draw light lines between your new bottom dot to each of the vanishing point dots on the top of the big triangle.
3. Draw lines down from your book's three corners nestled inside the big triangle to indicate the book's edges, as shown (Figure 6).

TIPS AND TECHNIQUES

Guidelines connecting to the vanishing points will help you place the words and images on the book's cover too! Here's how:

1. Place dots representing the bottom of the title box and the top of the author's name box as shown. Draw lines down from those dots (on the book's spine) (Figures 7 and 8).
2. Connect these new dots to the opposing vanishing point with lightly drawn guidelines. Use those lines to place the biggest horizontal boxes on the cover (Figure 9).
3. Now make yourself a guideline for the title box. Guesstimate where to pop a dot where the title box ends (under the word "Days"), and lightly connect it to the opposing vanishing point. Sketch in the content—no need to be exact (Figure 10).

MEASURING SHORTCUTS

▶ The spine of the book is about a third longer than the bottom edge of the book.
▶ Use the "pencil-measure" hack (page 6) to determine relative book edge length.
▶ Every rectangle on the front cover of the book has different **dimensions**. There's no need to match these exactly.

3.

4.

5.

6.

7.

8.

9.
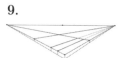

10.

DRAW THAT BOOK!

 1. Draw Your Blueprint

10 minutes!

Draw lightly!

- ▶ Draw a large triangle, and place dots at each point (see hacks, page 143).
- ▶ Nestle the book shape into the triangle. Draw dots for the book spine's and book bottom's ends, then connect those dots to the dots at the ends of the triangle's top line (see page 143) (Figure 1).
- ▶ Draw the book's spine and bottom edge (see hacks, page 143).

1.

 2. Add the Cover

10 minutes!

- ▶ Draw placeholders for big horizontal text blocks on the cover using hacks (page 143).
- ▶ Place the title box by connecting an **anchor dot** to the opposing vanishing point dot.
- ▶ Add more guidelines as you need them.
- ▶ Roughly sketch and scribble the content of the cover (Figure 2).
- ▶ Erase any extra lines on the book cover and spine.

2.

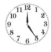 **3. See the Light**

5 minutes!

Notice where the light strikes this image.

3.

4.

5.

- ▶ Add **shading** to the various text boxes to hint at different colors (Figure 3).
- ▶ Now notice where the light strikes this image.
- ▶ Shade in the darkest darks where the spine touches the surface (Figure 4).
- ▶ Shade middle tones (Figure 5).

4. Finish Up!

5 minutes!

- ▶ Erase the external triangles, guidelines, and dots.
- ▶ Clarify the text and images on the cover.
- ▶ Darken and define the shadows (Figure 6).
- ▶ Snuggle up and read a book!

6.

BONUS CHALLENGE: PERSPECTIVE PRACTICE

Objects nearer to us look larger, and objects farther away look smaller. This holds true for individual objects—the front parts look bigger than the back, and any lines connecting the front to the back need to slant—which is why we couldn't draw the book by drawing a simple rectangle shape.

How much do they slant? The technique we've been using is called **two-point perspective**, where all lines in the drawing align to two single points on a **horizon line** called the **vanishing points**.

Let's practice by changing the perspective a little on the book we just drew. Move the bottom dot of the big triangle. The lines drawn to the vanishing points will dictate the rate at which the object gets smaller as it goes backward in space.

Let's try it! We'll move the book over to the right and farther away.

1. Draw a big triangle, this time placing the bottom dot over to the right and farther away from you than in your first 30-minute drawing (Figure 1).
2. Pop in dots and guidelines to nestle your book in the triangle (see page 143).
3. Add the spine and bottom edge (see page 143) (Figure 2).
4. Shade the areas that are away from the light, and darken where the book rests on the surface (Figure 3).
5. Erase the extra lines.

1.

2.

The guidelines show you exactly how to angle your lines to create accurate perspective no matter where you put your object. You can even make it hover above the horizon!

3.

Eventually you'll begin to draw proper perspective instinctively. Thirty-minute drawing is a great way to learn.

30-MINUTE SEASHELL

I'm blown away by the innate beauty of design found in nature. Called **natural design**, the patterns of color, shape, and line repeated within objects like seashells, fish scales, flower petals, tree bark, feathers, and so many others are everyday miracles, easily taken for granted.

LOCATION
I'm drawing this seashell at my parents' house in Carlsbad, California.

Seashells have always been my favorite source of natural design inspiration, something I'm reminded of whenever I visit my parents in California. Their house is a living gallery of art they've collected from Mexico and Santa Fe over the past thirty years. Elegantly placed among their displays are bowls of seashells they've gathered from the shore. I often find myself drifting for hours through their collections while carrying my favorite seashell from the nearest bowl.

SEASHELL DRAWING TOOLS

- ▶ Pencil
- ▶ Eraser
- ▶ Paper to draw on—or use the practice page 151
- ▶ Cup
- ▶ Penny
- ▶ Your finger
- ▶ Stumpy

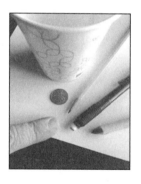

TODAY'S SEASHELL

Incredible natural patterns and shine—gorgeous.

SHAPES IN A SEASHELL

DECONSTRUCTED SEASHELL

Before You Begin . . .
Read these two pages.
No drawing yet!

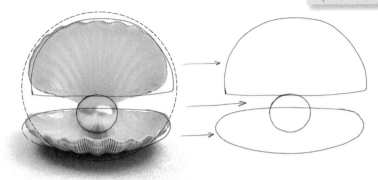

In the photo see the circle for the pearl, the half-circle for the top of the shell, and the oval for the bottom of the shell? I find it easy to get these shapes in place on paper by putting them all inside a big **holding circle**, which I hack by tracing a large cup or can. More keys to this drawing—the lines fanning out on the inside of the shell say "seashell" to us, and the **shadows** and **highlights** make the pearl pop and shine.

30-MINUTE SEASHELL HACKS

Holding Circle

Lightly trace a large cup or soda/pop can in the middle of your drawing page to create a visual guide for the **blueprint** (Figure 1).

Penny for a Pearl

Trace a penny to hack the pearl (a ring works too) (Figure 2).

Finger for Oval

If you'd rather not draw the oval shape for the bottom shell free-hand, trace your finger, then flip the paper around and trace it again for the other side of the oval (Figure 3).

MEASURING SHORTCUTS

- ▶ The top and bottom of the shell are the same width.
- ▶ The top of the pearl only slightly **overlaps** the top shell.
- ▶ The pearl is twice as tall as the visible outside of the bottom shell.

TIPS AND TECHNIQUES

Place the ridges that fan throughout the top and bottom of the shell using an **anchor dot**. Bring them to life with thoughtful **shading** and highlights.

Anchor Those Waves

▶ Draw an **anchor dot** on the center of the pearl to create a **focal point** (the spot that will attract the viewer's attention) (Figure 4).

▶ For both the top and the bottom of the shell, draw the center ridge lines first, then add the lines on each side, increasing the curve as the lines fan out (Figure 4). *The lines don't have to match the lines in the photo perfectly!*

▶ The lines on the outside of the bottom shell also slant away from the middle (Figure 5).

Shadows and Highlights

1. Shading those ridges can be a little tricky—too much can muddy up the drawing. Try this: first, squint to see the large areas in shadow in the photo. Ignore the ridges for now. I see shadowy areas:

 ▶ On the top edge and behind the pearl on the top shell
 ▶ On the bottom, top, and middle of the pearl
 ▶ Under the pearl and around the top of the bottom shell
 ▶ Under the bottom shell, in two levels of darkness

 When you shade these areas, vary the direction of your pencil lines with the shape of the shell as shown (Figure 6).

2. Add another layer of shading to the darkest areas (under the shell, under the pearl, and around the pearl) (Figure 7).
3. Using the stumpy (see page 6) or your finger, blend the shading (Figure 8).
4. When you finalize the drawing (Finish Up! on next page), add shadow to some ridges for emphasis, and then erase adjacent ridge-shaped highlights (Figure 9).

4.

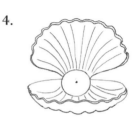

5.

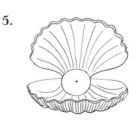

6.

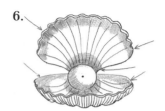

7.

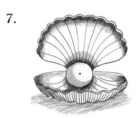

8.

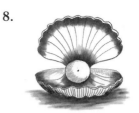

9.

DRAW THAT SEASHELL!

1. Draw Your Blueprint

5 minutes!

Draw lightly!

1.

- ▶ Draw a holding circle. **Bisect** the circle with a line to form the half-circle for the seashell top (Figure 1).
- ▶ Add a circle for the pearl (Figure 1).
- ▶ Draw an oval for the seashell bottom (Figure 1).
- ▶ Draw two lines connecting the top and bottom of the shell (Figure 1).
- ▶ Erase the extra lines (Figure 2).

2.

2. Shape the Shapes

10 minutes!

3.

- ▶ Draw the visible wiggles on the top and bottom of the shell (Figure 3).
- ▶ Thicken the edges by drawing another line next to the wiggles, mirroring the first lines. Draw a wiggled bottom on the shell bottom (Figure 4).
- ▶ Erase the lines behind the wiggles.
- ▶ Add an **anchor dot** in the center of the pearl. Draw ridge lines inside the top and bottom of the shell (see page 149) (Figure 5).
- ▶ Draw detail on the outside bottom shell (Figure 6).

4.

5.

6.

3. See the Light

10 minutes!

Notice where the light strikes this image.

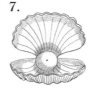
7.

- ▶ Squint; sketch large areas in shadow (see tip, page 149) (Figure 7).
- ▶ Add another layer of shading to the darkest areas (Figure 8).
- ▶ Blend shadows with your finger or stumpy.

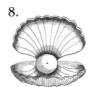
8.

4. Finish Up!

5 minutes!

- ▶ Erase extra lines (Figure 9).
- ▶ Shade next to the ridge lines (Figure 9).
- ▶ Erase highlights on the ridge lines and the pearl (Figure 9).
- ▶ Shade the darkest darks, and darken the outside edges (Figure 10).

9.

10.

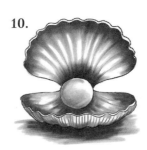

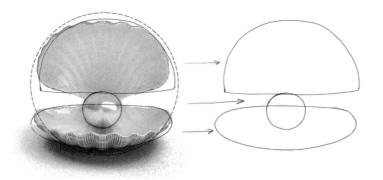

BONUS CHALLENGE: SIMPLE SNAIL SHELL

I'm still in a shell-drawing mood. Snail shells are easy to **blueprint**, and just a little careful shading makes them look realistic. So much fun to draw!

1. Draw a circle, about an inch in diameter (hack with a quarter if you like) (Figure 1).
2. Extend the top of the circle as shown (like a backward number 6) (Figure 2).
3. Curve the outside line as shown, connecting to the original circle about halfway down (Figure 3).
4. Add a curved line to illustrate the opening of the shell and a small oval as shown (Figure 4).
5. Erase the extra line. Have fun shading and creating the swirling pattern with blended tones (Figure 5).

1.

2.

3.

4.

5.

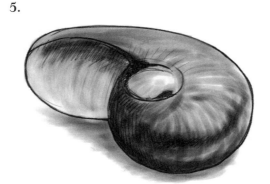

30-MINUTE BALLET SLIPPERS

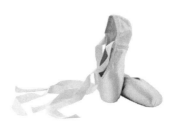

Oh, ballet slippers! I can't look at a picture of ballet slippers without thinking of my daughter's first ballet class. Takes me back to such innocent and adorable days! The tricky part of drawing ballet slippers is drawing the ribbons, so I use dots, grounding lines, and **relative placement** to figure out where they go. In fact, this whole lesson is about **placement** of ballet shoe parts relative to *other* ballet shoe parts. It's an intricate dance!

LOCATION

I'm drawing these at a dance studio, just about to teach a drawing workshop.

BALLET SLIPPERS DRAWING TOOLS

- ▶ Pencil
- ▶ Eraser
- ▶ Paper to draw on—or use the practice page 157
- ▶ Your thumb

TODAY'S BALLET SLIPPERS

Let's make these shoes dance off the page!

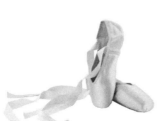

SHAPES IN BALLET SLIPPERS

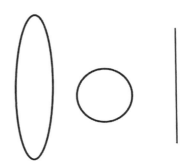

SHAPES IN BALLET SLIPPERS

Before You Begin . . .
Read these two pages.
No drawing yet!

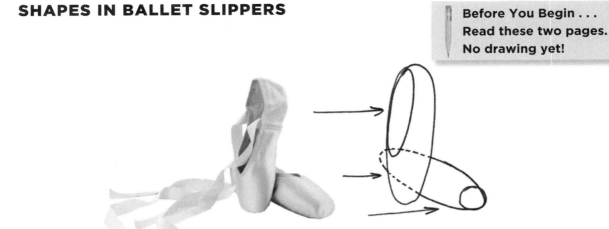

DECONSTRUCTED BALLET SLIPPERS

Four simple shapes jump out at me—a circle and three ovals: two ovals for the shoes them-
selves (one **overlapping** the other) and a smaller oval for the inside of the standing shoe. I
see a clearly defined circle on the toe of the back shoe. I don't see a clearly defined simple
shape for the ribbons, so I leave them out of the **blueprint**.

30-MINUTE BALLET SLIPPERS HACKS

Make the Ovals with Your Thumb

▶ Trace your thumb, then flip the paper upside down and trace your
thumb again to make the rough oval shape of the standing ballet
slipper (Figure 1). Near the spot where your thumb tracings met
in the middle, draw an **anchor dot** or an "X" to help you place the
other objects on the page (Figure 2).
▶ Place the oval for the back shoe using your thumb, as shown. See
the anchor dot peeking through? (Figure 2).

MEASURING SHORTCUTS

▶ Place the slippers on the far right of your page to make room for
drawing the ribbons.
▶ The distance from the **anchor dot** to the top of the back shoe
is about the same as the distance between the bottoms of each
shoe.
▶ The bottom of the opening in the front shoe is level with the top
of the back shoe where it intersects the front shoe.
▶ The length of the standing shoe and the distance the farthest
ribbon extends away from the shoes is about the same.

TIPS AND TECHNIQUES

Ribbon Placement

Ribbons look "ribbony" when they're drawn narrower and wider at turns and when the backs and fronts are differentiated through **shading**.

First, draw a light oval-ish shape, about the length of the standing slipper, in which to position the ribbons (Figure 3). Trust me—this will keep your drawing from getting all out of proportion!

Ribbon Tops

Place dots where the standing shoe's ribbons bend to create a map. Look at the **placement** of each curve to place the next one. It's all relative!

1. Dot these spots (Figure 4):
 ▶ Where the outside ribbon connects to the standing shoe (just above the heel line)
 ▶ Where the inside ribbon connects to the shoe
 ▶ Where the outside ribbon comes to a point (straight across from the heel line)
 ▶ Where the inside ribbon bends (straight across from the bend in the outside ribbon)

 Connect the dots to make your first two lines (Figure 4).

2. Continue to place dots where the ribbon bends, and connect with lines (Figure 5).
3. And so on.
4. Do the same for the next ribbon. Remember, draw only the top line of the ribbons for now (Figure 6).

Ribbon Bottoms

Use your eye when drawing in the bottoms of the front shoe's ribbons—the dots are where the ribbons bend, so they usually also mark the narrowest parts of each ribbon. Erase any overlapping lines (Figure 7).

Back Shoe Dots and Lines

Here's where I placed dots and drew the top and bottom lines of the back shoe's ribbons (Figure 8).

3.

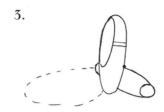

4.

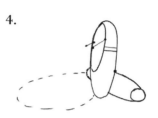

5.

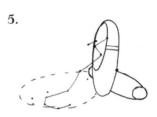

6.

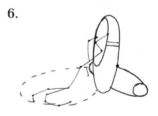

7.

8.

DRAW THOSE BALLET SLIPPERS!

1. Draw Your Blueprint

5 minutes!

Draw lightly!

1.

- On the *far right side* of the facing page sketch the basic shapes in the ballet slippers—overlapping ovals for the shoes, a smaller oval for the standing shoe's interior, and a circle for the toe of the other shoe (Figure 1).
- Use **placement** tips and hacks from the previous pages if you like.
- Erase lines where shapes overlap (Figure 1).

2. Draw the Ribbons: Lines First

15 minutes!

2.

- Draw the heel lines.
- Sketch an oval to position the ribbons (Figure 2).
- Dot and draw the top lines of the standing shoe's two ribbons (see page 155) (Figure 3).

3.

- Add the standing shoe's two ribbons' bottom lines (Figure 4).

4.

- Dot and draw the top and bottom of the back shoe's two ribbons (Figure 5).

5.

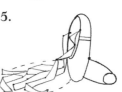

3. See the Light

5 minutes!

Notice where the light strikes this image.

6.

- Use the toe circle as your guide to place the **shadow** on the back shoe (Figure 6).
- Lightly shade in *all* the shadows you see—keep everything about the same value (Figure 6).
- Darken the darker shadows, both in the shoes and on the ribbons. This will make your drawing pop (Figure 6).
- Blend the shading on the ballet slippers with your finger to make them look smooth.

4. Finish Up!

5 minutes!

- Erase the toe circle, leaving just a hint of shadow.
- Add dark lines and a dark shadow where the slippers touch the ground, where they **overlap**, and wherever else you see some definition is needed.
- Add detail to the stitching lines and the front toe.
- Erase extra lines, and erase any shading that is in the brightest areas (Figure 7).

7.

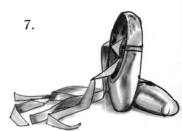

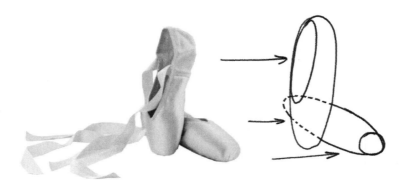

BONUS CHALLENGE: RIBBON

There's more than one way to draw a ribbon! Here's a fun way to draw a different kind of ribbon . . . with far fewer dots! (Yet another ribbon technique can be found in Lesson 1, 30-Minute Banana, page 9.)

1. Pop two dots onto your paper, a couple of inches apart (maybe the width of three fingers). Draw a squished circle between the dots (Figure 1).
2. Draw two more squished circles adjacent to the first as shown, each about the same **size** (Figure 2).
3. Find and define the top edge of your ribbon as shown (Figure 3).
4. Erase the extra lines (Figure 4).
5. Draw vertical lines down from the corners of your first squished circle. Draw two more "peek-a-boo" lines down from the very edge of the back circles as shown. This creates a very cool folding visual effect! (Figure 5).
6. Draw the bottom of the front part of the ribbon, curving it *more* than you think you need to. The part of the ribbon you want to appear closest to your eye must be drawn larger and lower than the parts you want to recede. Add a couple of dots to remind yourself where to place the bottoms of the back parts of the ribbon (Figure 6).
7. Complete the ribbon as shown by completing the back of the ribbon and then shading. See how I made the farthest parts of the back ribbon smaller than the ends because I want the ends to appear closer? Now decide where the light is coming from. Keep the parts of the ribbon closest to the light white. Shade the parts farthest from the light, then make the spots where the ribbons **overlap** the very darkest. Don't forget to shade inside the ribbon near the peek-a-boo lines (Figure 7)!

Hey, I think you've earned a blue ribbon!

1.

2.

3.

4.

5.

6.

7.

Glossary of Art Terms Used in This Book

Anchor dot: A dot drawn for use as a reference point for the rest of the drawing (sometimes called a "guide dot" in this book).

Bisect: Divide an object down the middle. In this book I often use the term "bisect" to describe drawing a line that divides a shape in half.

Blueprint: In this book, a quick map for a drawing, usually consisting of basic geometric shapes.

Cast shadow: The shape under and to the side of the object that is cast away—like a fishing line—in the opposite direction from the light source. The shape of the shadow is a squished or distorted version of the object casting the shadow. A cast shadow grounds the object and helps it look realistic.

Contour lines: Carefully placed, repetitive curved lines within an object that give it volume and a round shape.

Cuboid: Sometimes called a "rectangular cuboid" or a "rectangle prism," this is a three-dimensional-looking cube with a rectangle shape. (Thank you, Google!)

Dimension: The illusion that the drawing has depth.

Distortion: See **perspective**.

Focal point: The point of the drawing that draws viewers' attention; used as a reference point for the artist.

Foreshortening: Distorting an object by squishing the shape to create the illusion that one part of it is closer and one part is farther away.

Hatching: A shading or toning technique created by drawing closely spaced parallel lines. You can further increase variations in tone by using **cross-hatching**, which is drawing additional layers of parallel lines, with each new layer of parallel lines drawn in a different direction from the layer below it.

Highlights: Where light hits an object directly; usually the brightest parts of an image. Highlights are most common in rounded objects like spheres and cylinders.

Holding line, or holding circle, or holding box: A line or shape drawn on the page to help you place other parts of the drawing. In this book I also call such lines "guidelines" or "anchor lines." These lines and shapes are usually eventually erased.

Horizon line: A horizontal reference line that helps create the illusion that objects in the picture above or below that line are either closer or farther away.

Hot spots: See **highlights**.

Light source: The source of the light on any object, like a lamp or the sun. The placement of the light determines what will logically be in shadow on your drawing. The shadows and shading will be on the opposite side of the drawing, the side that faces away from the light.

Natural design: Designs—colors, shapes, patterns, lines—found in nature.

Negative space: The space around an object, notable especially when the space itself forms a definable shape. Sometimes it's easier to create an accurate drawing of an object by drawing the space around it rather than the object itself.

Organized chaos: The process of adding texture to an object in a random style to imitate nature, such as grass blades, tree leaves, animal fur, and so forth (see **planned randomness**).

Overlapping: When one object is deliberately drawn partly over another object, blocking part of that object from view. This is done to create the visual illusion that the object drawn over the other is closer.

Perspective: Using the relationships between objects on a page to determine sizes, distances, shapes, and so forth within the drawing.

Placement: When an object is drawn lower on the surface of the page to make it appear closer to your eye.

Planned randomness: The deliberate use of random pencil strokes to create a "messy" or "fuzzy" look (see **organized chaos**).

Relative size, or relative placement: Determining the size of one part of a drawing in proportion to the sizes of other parts of the drawing.

Shading: Drawing and blending dark lines on the parts of an object that are opposite or hidden from the light source, to create the illusion of depth and dimension.

Shadow: Darkness on an object, or on part of an object, or the ground under and adjacent to the object, away from the light source.

Size: A larger object appears closer; a smaller object appears farther away.

Smudge Shield: A clean scrap of paper placed over finished parts of your drawing on which to rest your hand while you draw other sections.

Tapering: Drawing the farther-away parts of an object more narrowly to create the illusion of depth. Some objects, of course, have naturally tapered shapes—tree trunks are wider at the base than at the top, arms taper from shoulder to wrist—and the term "taper" is used to describe this as well.

Two-point perspective: Where two sides of an object each have their own **vanishing point**. Often those vanishing points may be outside of the drawing!

Vanishing point: As parallel lines (like a railroad track) move away in the distance, they taper in toward each other. The point at which they converge and disappear is called the "vanishing point." You can place the vanishing point anywhere on the **horizon line** and draw all parallel lines in the drawing through that point. Drawings can be designed with multiple vanishing points (see **two-point perspective**).

Acknowledgments

BIG THANKS AND SMOOCHES TO FRIENDS AND FAMILY:

Jonathan and Brandy Clark, Robert Neustadt, Jonathan Hayward, Jody Rein, Jonathan Little, Amanda and Bret Fuhrmann, Joshua and Amelia Templeton, Chris Murphy, Dorothy Kittaka, Doug and Wendy DeVore, Tim Decker, Jaimee Hazlewood, Tommy Simms, Gabriel and Jon Wheeler, Trent and Janice Heffner, Abby Salazar, Lauren Holmes, Brett Walter, Coy Mitchell, Crissy Butts, Paul and Brynn, Dennis Kelly, Raja Abushar MD, Scott McAuley, Susie Hoover, Anat Ronan, Jake Mackasey, Ginger Simon, Quirt Crawford, Karen Lotito, Rebecca Evans, Bevan Iredell, Eve Ross, Nate Skaggs, Ryan and Maddi Shaw, Foye and Dajam Stanley, and Ken Welch III.

GRATITUDE TO AMAZINGLY SUPPORTIVE COLLEAGUES:

Max Meyer, Fort Wayne Museum of Art, Kris Hensler, WFWA Fort Wayne PBS, Sam Ellis (*Archer* and *Adventure Time*), Guy Gilchrist (*Muppets*, *Nancy*, *Tom & Jerry*), Tom Cook (*He-Man*, *Scooby Doo*, *The Smurfs*), the late C. Martin Crocker (*Space Ghost*), Phil Ortiz (*The Simpsons*, *The Smurfs*, *The Chipmunks*), Mike Toth (*Mulan*, *Hercules*, *Tarzan*), Tom Bancroft (*The Lion King*, *Beauty and the Beast*, *Pocahontas*, *Veggietales the Movie*), Dewayne Holmon and his amazing talent tribe at SoulGate Studios, all my artist buddies of the Houston Drawing Board, Meredith Vogtman and JR Warren and the awesome crew of Houston's Comic Palooza, Alex Rae and Kate Ruark of Wizard World Comic Cons, Haley Stroup, Renee Sedliar, Katie McHugh, and the spectacular team at DaCapo Press!

SPECIAL THANKS TO GUEST ARTISTS WHOSE WORK INSPIRED OR APPEARS ON THESE PAGES:

Siera Pritikin, Rod Thornton, Anat Ronen, and Rosel Rodriguez!

So many more friends, family, fans, and students have supported me in this two-year process to write this book, it is impossible for me to list everyone here! I hope that you *know* who you are and that I'm so grateful for your kindness, generosity, and friendship.